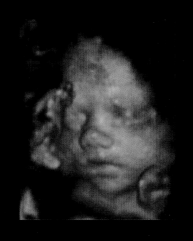

IN THE WOMB

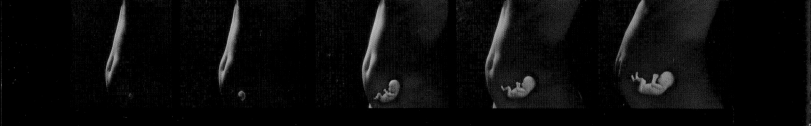

IN THE WOMB

PETER TALLACK

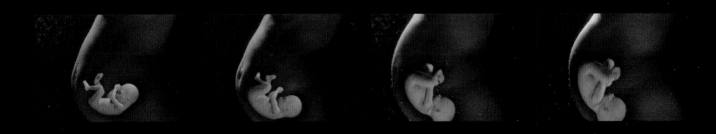

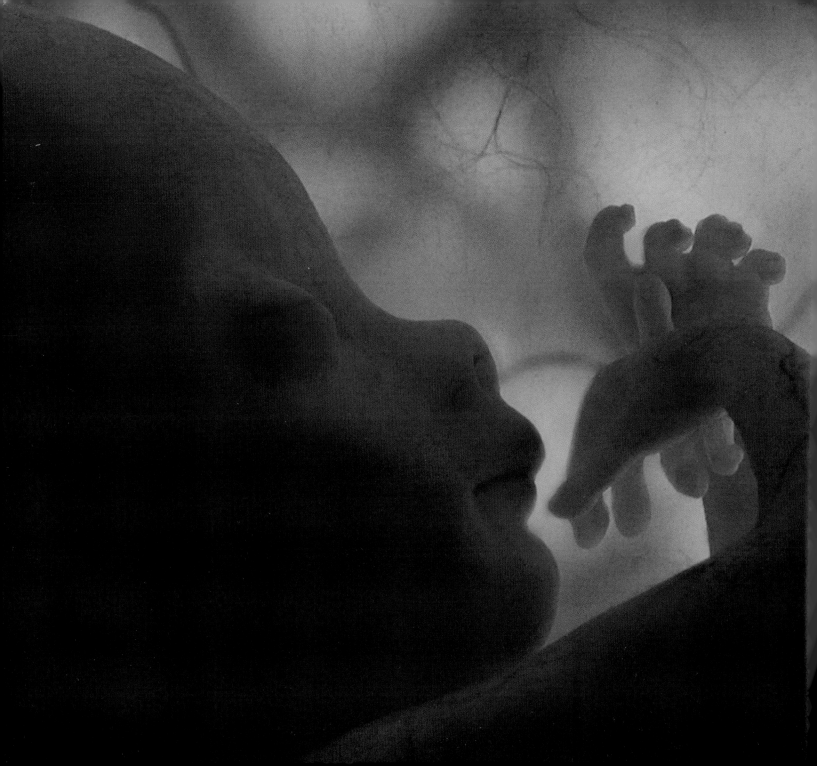

CONTENTS

Page 1, Soon-to-be offspring: 3D ultrasound of baby.
Left, Baby: Exploring the womb.

FOREWORD

Walk into any bookstore these days, and you'll find a whole lot more than nine months' worth of books for prospective parents. Some books promise to answer every question an expectant parent could ask (and lose sleep over)—from the most common ("Is it normal to have morning sickness all day and night?") to the more esoteric ("Is it safe to keep snowshoeing?"). Others advise moms-to-be how to eat well for two and how to transition cozily to a threesome. Still others explore the emotional side of pregnancy (and you thought the roller-coaster rides at Six Flags were harrowing?), tackle the practical side (did you know that dark prints best hide the sauce stains your belly keeps attracting?), and even get physical (goodbye, Mama Couch Potato; hello, Marathon Mom?). A few books cover the latest medical innovations, from the high-tech to the complementary and alternative. And then there are books that offer a glimpse into what expectant parents can expect during the amazing nine months of growing a baby.

It was my own first journey through those 40 weeks (actually, it was more like 42 weeks—and, believe me, I was counting) that served as the inspiration for my book *What to Expect When You're Expecting.* Conceived during a moment of particularly high anxiety (of which I had plenty during my nine months), I wrote it as a mom on a mission, a mission to help other expectant parents sleep better at night than my husband Erik and I did. Unable to find the answers to my hundreds of questions or the reassurance for my thousands of worries in another book—or to find that information written from a woman's perspective (many of the pregnancy volumes back then were written by obstetricians...male obstetricians), I decided to deliver one that would. And the *What to Expect* series was born, along with my daughter Emma.

When I first wrote *What to Expect,* the science of embryology was still locked away in medical textbooks. We already knew—and had written—plenty about what a mother goes through during pregnancy, from those first waves of nausea to those last contractions, but expectant parents could do little but speculate on what their soon-to-be offspring were experiencing as they developed from fertilized eggs to bouncing babies. That fantastic nine-month voyage that transforms a ball of cells into a bundle of joy was shrouded more or less in mystery, leaving parents in the dark about the budding life growing within those uterine walls.

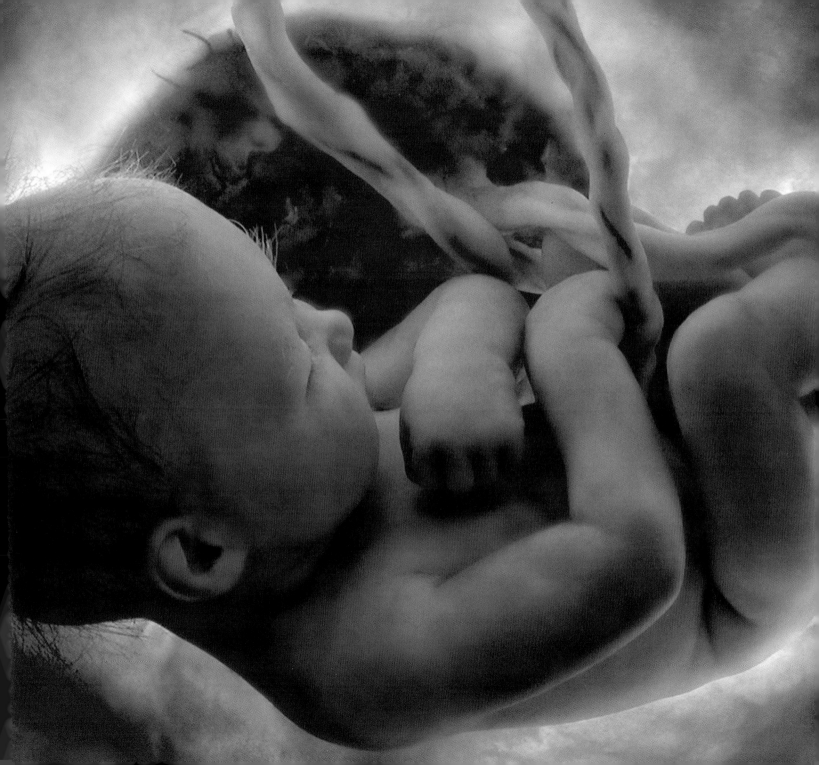

Lights on—spotlight, baby. Finally, there is *In the Womb,* the first book to chronicle pregnancy from a developing baby's perspective—to open a window into this incredible world. By taking readers on an eye-popping visual tour of gestation, from conception to birth, *In the Womb* asks—and tries to answer—questions that have intrigued and confounded curious parents (and obstetrical practitioners) throughout the history of baby-making. Why do we reproduce the way we do? Why is the egg so much bigger than the sperm? How does a fertilized cell know how to organize itself? How does the head end up on top—and those cute little feet on the bottom? How are twins formed? What does a fetus feel, and what can it hear or see or taste? Does it react to its mother's fears, or to her happiness, or to her hunger? What triggers birth? How does a baby know which way is out and which end should be up when it's time to exit? And in what ways is the future of a baby's health written during that stay in the womb?

In the past two decades, we have learned enough about the science of pregnancy for almost the whole story to be told and to be shown in the pages of this ground-breaking book. It is an awe-inspiring story that takes us to the frontiers of modern biology and medicine and that delves deep into our evolutionary history. *In the Womb* allows us for the first time to see how something as incredibly complex as a fully equipped, suitable-for-hugging baby develops in the space of just nine months—how it generates functional organs, how it sprouts tiny fingers, toes, and ears, how it puts on layers of soon-to-be-pinchable fat, how it grows in length, how it becomes recognizably human, how it begins making an intricate network of brain connections that will one day help it with algebra homework, how it develops remarkable reflexes that will ease its transition from the womb to the real world, and how it behaves in ever more sophisticated ways.

And you don't have to be pregnant to enjoy the ride, either. Though our baby-making days are behind us, Erik and I watched *In the Womb,* the National Geographic Channel's mesmerizing television program about the miracle of pregnancy, with unabashed wonder (and just a touch of regret that we've since retired my womb). It was incredible to see how far we've come in just two decades in our ability to understand, but most of all, see, what a baby's journey is really like. When I was pregnant for the

first time, the only image I had of the baby inside me (besides my fantasized ones) came from an extremely blurry ultrasound screen. Even with the technician's patient pointing, we still couldn't figure out which end was up or why neither of the ends looked even vaguely human. The only peek we and other expectant parents had inside the uterus besides that fuzzy one were the pictures in Lennart Nilsson's classic text (which two-year-old Emma pored over to try to make sense of the little brother we were expecting).

Today, parents get to bond with their offspring long before they actually meet them, not just from those early kicks and pokes (and amusing bouts of hiccups) but from actually seeing their babies in action—*in utero*. With the advent of new ultrasound imaging techniques, we can gaze into the womb with astonishing new detail—in 3D and 4D (the next best thing to cuddling). Incorporating this technology with stunning animation, the broadcast of *In the Womb* was literally able to give us a womb with a view, a view that peeled away the layers of mystery from inside the uterus and finally brought into focus those once blurry images, that allowed us to see a baby's development from a baby's point of view. So that parents could experience pregnancy, at long last, from the inside out.

Like the television program *In the Womb*, this book, with its clear, comprehensive, and fascinating text by Peter Tallack and its riveting illustrations, provides a vivid and compelling account of the extraordinary steps in a baby's development and relates them directly to the remarkable adaptations that the mother's body will make (not always happily!), allowing both mothers- and fathers-to-be to enjoy and appreciate pregnancy as never before.

I hope you enjoy this book as much as I have—and may all your greatest expectations come true!

Heidi Murkoff

INTRODUCTION

At the moment of conception, every human embryo embarks on an incredible nine-month journey of development. This book originates from a television program that tracked the journey from conception to birth using groundbreaking filming and scanning techniques as well as cutting-edge animation. This stunning documentary was first shown in March 2005 on the National Geographic Channel in the United States and on Channel 4 in the United Kingdom.

Five ultra-realistic and anatomically accurate models were required to engage the audience and represent the fetus (complete with placenta, umbilical cord, and membranes) at key stages of development that would be impossible to film for real. They were constructed by Artem, a specialist model-making and visual-effects company, and filmed by Dr. David Barlow.

If you have seen one of his television film clips, you may have enjoyed a journey down a blood vessel or watched in amazement as you were taken through the valves of a pumping heart. Barlow is one of the most accomplished and respected biological filmmakers and has pioneered some innovative techniques to convey the complexity of biology in an understandable way. He has won three awards from the U.K.'s Royal Television Society and the Lennart Nilsson Award for scientific photography, and has been nominated for a British Academy of Film and Television Arts award.

He developed his unique filming skills while studying for his Ph.D. at the University of Southampton, U.K., where he was researching the locomotion of insects. This research involved filming with microscopes and high-speed cameras, and took him into natural-history filmmaking for the BBC. He later branched out into

medical imaging and a cinematic eye for drama: Barlow photographed the stills, which were then animated by The Mill, one of the world's leading visual-effects companies. The sperm scene, in which the fertilization of an egg was caught on film through a powerful microscope, was first shown in an IMAX theater, and described by the director-producer Peter Georgi as "the greatest purely optical magnification in motion-picture history."

medical subjects and started mixing straight scientific photography with accurate simulation to cover "unfilmable" sequences. Until he devised ways to animate x-rays, film hairs growing, build scale models of beating hearts, and steer endoscopic cameras into the remotest corners of a living person, few photographers had been able to capture the body's internal workings.

For the television special *In the Womb,* he created things that allow us to visualize the unseeable. In one of its most powerful scenes, a shapeless bundle of cells expands into the hand of the fetus. Filming this sequence required both an intimate knowledge of

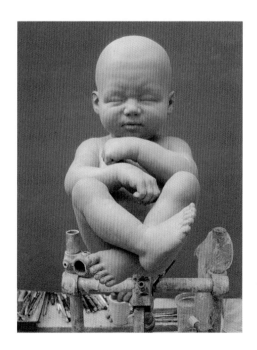

 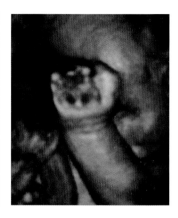

The models feature in more than 20 minutes of screen time and have to bear very close scrutiny. Each was sculpted in modeling wax, molded, cast in silicone rubber, and painted. The early-stage models had to reveal some of the complex structure of the developing organs including beating hearts. These organs were made as separate parts, which were then set within a translucent outer casting. Several novel techniques were used to enhance the finish, such as reverse-painting blood vessels into the mold and using transparent flock to create the tiny swirls of hairs on the skin.

The wombs were made from a series of large blow-formed acrylic domes layered with hand-painted silicone rubber. The coloring was carefully controlled so that the

material remained translucent for back lighting. The dark and dirty bouyant environment of the amniotic sac was conveyed by filming the models in tanks of water using special lenses to mimic real endoscopic footage of a fetus in the uterus. The earliest-stage model had a small air bladder that could be inflated rhythmically to provide a heart beat, while threads attached to the umbilical cord and the limbs enabled the model fetus to appear as if it were kicking and stretching out—always in ways seen in ultrasound scans.

Barlow's filming and animation were complemented by revolutionary ultrasound imagery that sheds light on the delicate, dark world of a fetus as never before. The images were produced by Professor Stuart Campbell, a

pioneer of ultrasound diagnosis who has introduced many standard techniques used in the prenatal examination of the fetus. Formerly academic head of the Department of Obstetrics and Gynaecology at King's College Medical School, he is a consultant at the Centre for Reproduction and Advanced Technology (Create Health) in London. He was the first president of the International Society of Ultrasound and Obstetrics and Gynecology, and is editor in chief of the medical journal *Ultrasound in Obstetrics and Gynecology*. He has been awarded many international honors, held visiting professorships in the U.S., and is honorary fellow of the American College of Obstetricians and Gynecologists.

First used in 1958, ultrasound scans are produced by transmitting short pulses of high-frequency but low-intensity sound waves through the uterus. The frequency of the sound waves is above the limit of the human ear, so a baby cannot hear the sound. The sound waves bounce off the baby and the returning echoes are translated by a computer into an image on a screen that reveals the baby's position and movements.

Bone and other hard tissues are white in the image because they reflect the biggest echoes; organs and other soft tissues appear gray and speckled; while amniotic and other fluids appear black because they do not reflect any echoes at all. The rebounding waves are collected to produce an image—the traditional two-dimensional "slice" used diagnostically. But Professor Campbell uses faster computers to process many 2D slices over a very short period of time and then stitches them together to produce 3D images. If the processing is fast enough (more than 40 frames per second), then the fetus appears to move in real time—images known as 4D scans.

For obstetricians, the development of 3D and 4D scans has been the medical equivalent of the Hubble Space Telescope, allowing researchers to scrutinize fetal development and behavior in unprecedented detail. Only with these advances was it possible to make a definitive film on life in the womb.

By combining Barlow's and Campbell's remarkable images of the private world of the fetus with an accurate chronological account of life before birth, *In the Womb* reveals how understanding the miracle of pregnancy is a scientific challenge that can inspire us all.

THE JOURNEY

This baby has come to the end of a nine-month journey. She can already taste, hear, smell, touch, and learn. Sounds are becoming louder, and she is being jostled and squeezed. After 266 days, her soft cocoon has grown increasingly cramped and uncomfortable, and there is only one way out. She is about to be thrust into an unknown world of bright lights, loud noises, and cold air—and there is no turning back.

The baby: Due date approaches →

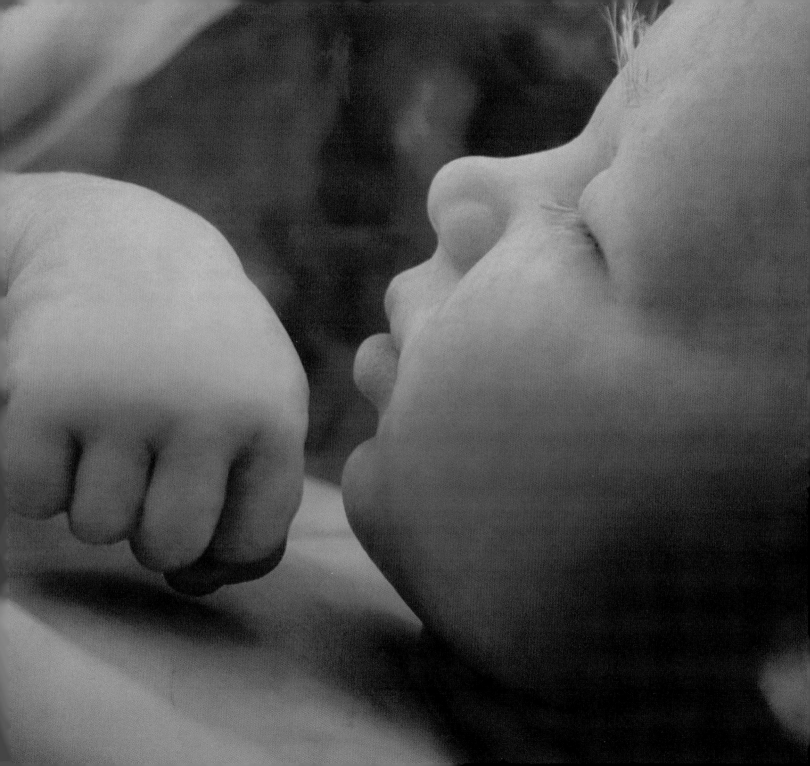

THE ITINERARY

This is the story as seen from inside the mother's womb: from the moment two cells fuse into one, to the birth of a baby girl.

She is about to begin the journey of a lifetime, but she has already completed the most dramatic nine months. In just 38 weeks, she has transformed from a single cell into trillions, including 350 specialized types, organized into the incredibly complex form of an infant girl.

Using new three-dimensional and even "four-dimensional" scanning techniques—which capture live action—a window is opening on the womb, allowing us to see fetal development unfold before our eyes. This footage combined with computer imagery takes us on a journey inside the womb that has never been seen before, and reveals that the fetus behaves in a much more sophisticated way than previously imagined.

During her odyssey in the womb, she will smile, recognize her mother's voice, and maybe even dream. The mother provides shelter and sustenance, but the real star of the show is the fetus herself, building and growing according to an intricate set of plans laid down at the moment of conception.

Most women chart the progress of their pregnancy in months, but doctors and midwives do their calculations in weeks. Because the date of conception is often uncertain, it is convenient to date pregnancy from the first day of the mother's last period, making a total of 40 weeks, or 280 days.

But ovulation and conception don't normally take place until around two weeks after the onset of the last period: In other words, two weeks will pass before sperm meets egg. So our baby's journey actually lasts 38 weeks, or 266 days, her age being the time since fertilization.

Pregnancy is normally divided into three "trimesters"of three calendar months each. Each trimester demarcates important milestones in her development. In the first trimester, all her organs and systems are established; in the second, her growth is rapid and she develops the ability to perform complex coordinated activities (and if born prematurely she could survive with intensive care); and in the third she puts on weight and develops behavioral patterns that prepare her for life outside the womb.

As for her size, measurements are from the top of her head to her bottom—the so-called crown-rump length or sitting height. All lengths, weights, and timings given in the book are approximate.•

Waiting in the womb: 38-week baby →

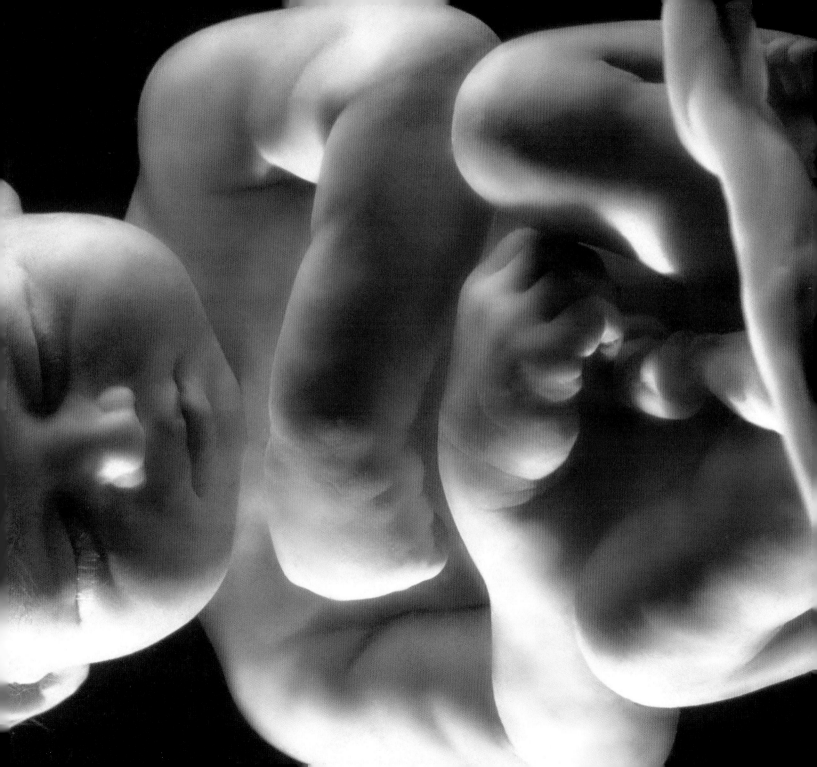

THE SPERM

Here's how it begins. During ejaculation, a mature, healthy man expels into a woman's vagina less than a teaspoonful of semen containing some 200 million to 600 million sperm. Each sperm carries a precious cargo—the father's set of genetic instructions—and is built for the express purpose of moving. It has a compact head with a nucleus housing the genes and a long lashing tail packed with mitochondria, the battery-shaped structures that provide cells with energy.

A man's testes are constantly at work, churning out more than 1,000 sperm every second. Each sperm has a life span of about 72 days. They mature and develop the ability to swim during the 12 days it takes them to pass through the epididymis, a 20-foot-long series of thin, coiled tubes. It's a complicated process that often goes wrong. Even in good-quality semen, up to 40 percent of ejaculated sperm may be abnormally shaped—they might have an overgrown head or a kinked tail, or have two heads or two tails, or even be headless. These unfortunates are unlikely to fertilize eggs—most are unable even to pass through the mucus in the cervical canal—but their presence doesn't seem to affect fertility unless they make up more than 85 percent of the total.

The quality of a man's sperm depends on his lifestyle. If he avoids smoking, excessive alcohol, hot baths, even tight underwear, he will produce healthier sperm in greater numbers. Allergies, environmental pollution, and radiation can also increase the proportion of abnormal sperm. Coffee, on the other hand, appears to stimulate sperm to swim farther, faster, and harder. In healthy sperm, more than half are likely to be strong swimmers, or "motile," but only around a quarter are able to move forcefully in one direction.

Even for the good swimmers it's a slow journey. They're the smallest cells in the human body and travel at 0.08 inch to 0.12 inch a minute, passing from the vagina through the muscular ring that forms the neck of the uterus, the cervix, up into the uterus and into one of the two Fallopian tubes where the woman's egg—the largest cell in her body—awaits.•

Densely packed: Sperm under an electron microscope →

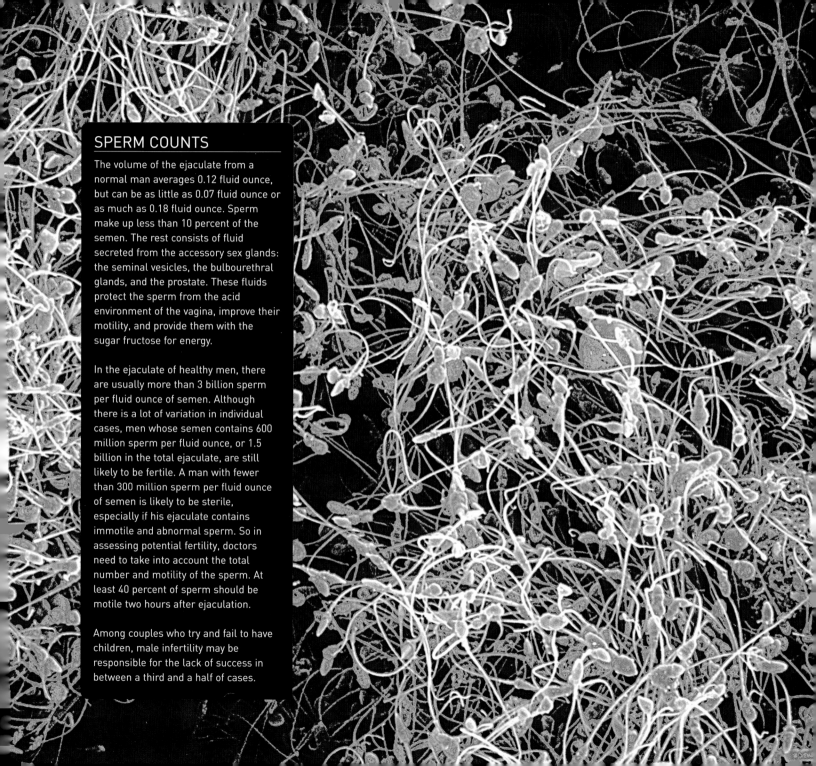

SPERM COUNTS

The volume of the ejaculate from a normal man averages 0.12 fluid ounce, but can be as little as 0.07 fluid ounce or as much as 0.18 fluid ounce. Sperm make up less than 10 percent of the semen. The rest consists of fluid secreted from the accessory sex glands: the seminal vesicles, the bulbourethral glands, and the prostate. These fluids protect the sperm from the acid environment of the vagina, improve their motility, and provide them with the sugar fructose for energy.

In the ejaculate of healthy men, there are usually more than 3 billion sperm per fluid ounce of semen. Although there is a lot of variation in individual cases, men whose semen contains 600 million sperm per fluid ounce, or 1.5 billion in the total ejaculate, are still likely to be fertile. A man with fewer than 300 million sperm per fluid ounce of semen is likely to be sterile, especially if his ejaculate contains immotile and abnormal sperm. So in assessing potential fertility, doctors need to take into account the total number and motility of the sperm. At least 40 percent of sperm should be motile two hours after ejaculation.

Among couples who try and fail to have children, male infertility may be responsible for the lack of success in between a third and a half of cases.

THE EGG

Each month, a woman's ovaries release a single egg containing her own genetic instructions. The cells that will become her eggs were created while she was still a fetus herself, nestled inside her own mother's womb. A woman is born with about 2 million potential eggs, but by puberty their numbers will have dwindled to around 400,000. She loses about 1,000 a month until the age of 35, when depletion accelerates.

Each month, as soon as her period ends, a hormone called follicle-stimulating hormone is secreted into her bloodstream by the pituitary gland, a small bean-size gland in the brain. This hormone acts on her ovaries, which lie at the end of her Fallopian tubes, and recruits a few eggs to develop. The recruited eggs each mature inside a fluid-filled bubble called a follicle, which starts to enlarge under the influence of follicle-stimulating hormone. Every month about 20 eggs start this process, but usually one dominant follicle becomes fully mature. The others shrivel and the eggs inside are lost.

The egg ripens to one side of the follicle, surrounded by a mound of special cells that feed it with nutrients and produce estrogen. This hormone enters the bloodstream and stimulates the growth of the lining of the uterus and breast tissues. As the level of estrogen in the blood peaks, it feeds back a message to the hypothalamus—a control center in the brain—telling it that the follicle is mature and ready to ovulate. The hypothalamus responds by instructing the pituitary gland to release a pulse of "luteinizing hormone," which triggers the release of the egg from the follicle about 36 hours later. This is ovulation, and it usually takes place around day 14 of the menstrual cycle.

Shortly after ovulation, the wall of the ruptured follicle collapses. Under the influence of luteinizing hormone, it is transformed into a glandular swelling in the ovary called the corpus luteum, which starts to produce progesterone as well as some estrogen. These hormones, particularly progesterone, make the uterus receptive to pregnancy by stimulating its cells to produce the nutrients needed to support a developing embryo and by thickening its lining.

Each ovary releases one egg—occasionally more—in alternate menstrual cycles, so ovulation takes place from only one ovary at a time. The released egg is surrounded by a clear, gelatinous coat—called the zona pellucida ("clear zone")—and an outer layer of follicular cells. At 0.004 inch in diameter, it is visible to the naked eye as a tiny speck.•

GETTING PREGNANT

Even a woman who never takes the contraceptive pill—which suppresses ovulation—will release only 400 or fewer mature eggs during her reproductive lifespan. Fertilization must happen between a few hours and a day after ovulation. So she has only about 400 days on which she can become pregnant during her lifetime. Fortunately because sperm can survive in her reproductive tract for a few days, she may conceive after sexual intercourse that takes place on any of 1,200 days (the day of ovulation and the two days before).

Ripened and ready: A mature egg surrounded by the zona →

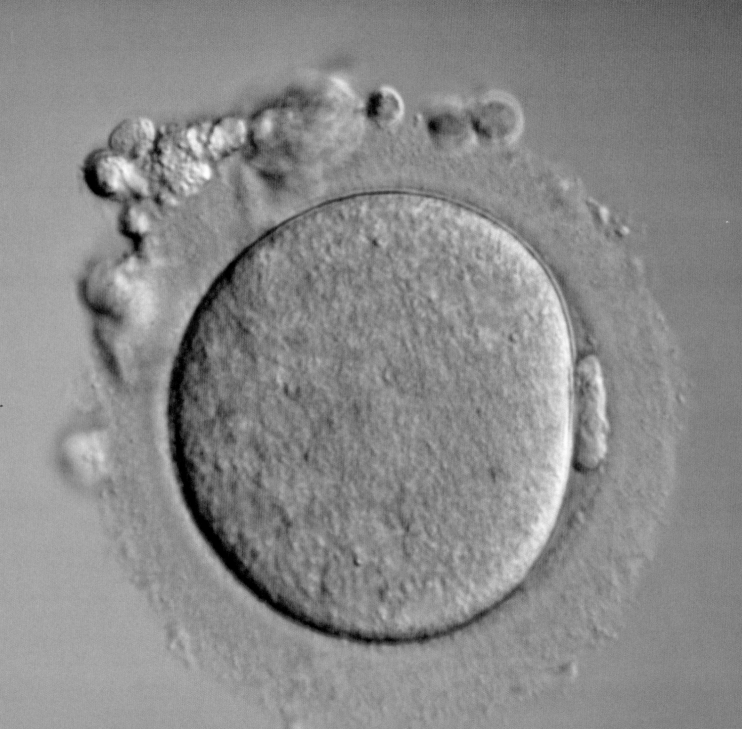

THE SPERM RACE

Sperm and egg are now on a collision course. After its release from the ovary, the egg is wafted into the Fallopian tube by delicate projections that resemble the tentacles of a sea anemone. Once inside, the beating of tiny hairlike strands called cilia gently propels the egg down the tube to the uterus.

How the sperm find their way to the egg is something of a mystery. Recent research indicates that sperm have a sense of smell and can sniff out their target: They bear odor receptors usually found in the sensory nerve cells of the nose, and these could allow them to swim toward chemicals drifting from the egg.

But it's largely down to chance. The journey is so arduous that only a couple of hundred sperm survive out of the millions that started out. From the vagina, fewer than 100,000 make their way through the cervix, and a mere 200 survive the journey up into the Fallopian tubes, regardless, it seems, of how many were ejaculated. And only one can fertilize the egg.

The first hurdle is the hostile environment of the vagina. Its secretions are acidic to prevent bacteria and other organisms from infecting the uterus and Fallopian tubes. Under the influence of enzymes from the prostate, the semen coagulates rapidly but then liquefies 15 to 20 minutes later. Coagulation protects the sperm against the acidic vaginal fluids and stops them from seeping out of the vagina before they can make headway in their journey. Within a minute or two, sperm are in the cervix, and within five to ten minutes some have passed through the uterus and into the Fallopian tubes. For the next 80 hours, sperm that pooled in the crypts of glands lining the cervix may continue to enter the uterus, though most of those ejaculated survive no more than 48 hours.

During their journey through the uterus the sperm become hyperactive and attain full fertilizing capacity. Once inside the Fallopian tubes they manage to swim upward, aided by muscular contractions of the uterus and tubes—an extraordinary feat given that at the same time the egg is being propelled in the opposite direction. The fastest sperm can swim to the upper end of the Fallopian tubes in about five minutes, although most get there in about 45 minutes and it may take up to 10 hours before the actual moment of conception.

The first sperm to reach the egg are the strongest and the fittest, and the first one to fuse with the membrane of the egg will be the winner.•

Homing in: Sperm meets egg →

SIZE MATTERS

Compared with the sperm, the egg is both massive and passive. Roughly the same diameter as a human hair, it is about 90,000 times as large as the sperm and it is immotile, whereas the sperm is highly vigorous.

This enormous disparity may result from an ancient evolutionary struggle. Long ago, sex cells were all the same size. But two different strategies for sexual reproduction emerged.

To increase the chances of fusing with another creature's sex cell, it pays to produce lots of your own sex cells that move around a lot: So natural selection favors small, active, and abundant sex cells—sperm. On the other hand, a large and well-stocked embryo will have a head start on the way to adulthood, so natural selection also favors sex cells that are big, stuffed with food, and reluctant to waste energy going places— eggs. An alliance of these two strategies explains the evolution of sperm (small, cheap, and plentiful) and eggs (large, expensive, and rare)—and even the evolution of the sexes themselves.

THE LONG RUN

A sperm has a head roughly a few hundred thousandths of an inch in diameter and is only ten thousandths of an inch in length. Each must travel up to four inches (2,000 times its own length) in the female reproductive tract before it

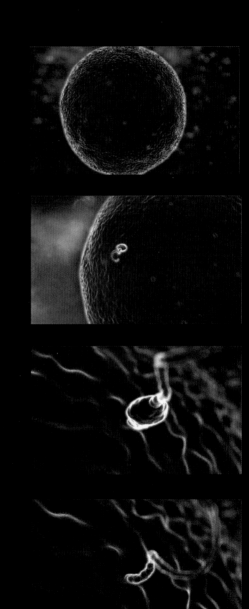

THE FIRST TRIMESTER

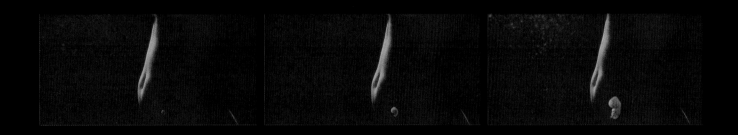

FERTILIZATION DAY 1

●

The sperm now faces the daunting task of wading through the follicular cells around the egg and then piercing its jelly-like coat, the zona pellucida.

For this it uses a special piece of equipment: a cap on its head that is packed with a potent cocktail of biological catalysts—enzymes. The enzymes work like a chemical drill. They are discharged through perforations in the cap, disperse the follicle cells, and allow the sperm to pass through to the zona. No single sperm seems able to get through by itself without the help of several hundred others: Nothing less than a full-scale chemical assault is needed.

On touching the zona, the sperm locks onto its surface and is totally transformed. Driven by a reinvigorated tail, it releases other enzymes that digest a pathway through the zona to the membrane of the egg. By now the sperm is denuded: Its cap has dissolved and the membrane of its head has disintegrated.

There are no prizes for coming in second. The instant one sperm sticks to and fuses with the egg's membrane, it triggers a change in the egg and zona that makes it impossible for any other sperm to get through.

The head and tail of the winning sperm enter the egg, leaving the sperm's membrane behind. The tail detaches and the sperm's nucleus is drawn toward the nucleus of the egg. The two nuclei gradually and gracefully become one. Fertilization is complete: Two sets of genetic material, one from the mother, one from the father, combine to make a new genetic message.

This is the moment of conception, when an individual's unique set of DNA is created—a human signature that never existed before and will never be repeated. The first cell has been created of what will become a new human life.

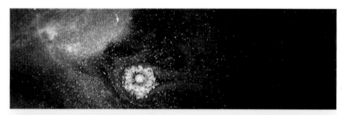

WINNER TAKES ALL

The egg has two main ways of blocking the entry of more than one sperm. First, fusion of a sperm with the egg changes the electrical and chemical properties of the egg's membrane, making it resistant to the binding of other sperm. Second, the electrical changes cause calcium to leak into the egg from the surrounding fluid, which in turn prompts the egg to expel special granules of chemicals that harden up the zona pellucida and destroy receptors on its surface that bind to sperm. So although several sperm begin to penetrate the zona, only one usually enters the egg and fertilizes it. This micrograph shows one such sperm on its way through the zona. But sometimes two sperm get through by accident. The resulting embryos look normal but are nearly always spontaneously aborted, unable to cope with the excess genes. They account for up to a fifth of all spontaneous abortions that happen as a result of chromosomal abnormalities.

Two become one: Fusion of egg and sperm nuclei →

GENES AND CHROMOSOMES

The genetic information in sperm and egg is stored in bundles called chromosomes—23 from the mother and 23 from the father. Each chromosome is made of a tightly twisted and packaged strand of DNA, the double-helix molecule that carries the genetic code. Unraveled and stretched end to end, the DNA molecules in a human cell would be more than six feet long.

Scattered along the length of this twisting ribbon of DNA are genes—sequences of chemical letters that spell out the information needed to make particular proteins. Genes hold the key to our uniqueness because the proteins they code for make up most of the machinery that runs a cell.

It takes between 20,000 and 25,000 genes to make a human, roughly the same number as are needed to make a chicken. All of us have a complete set from each of our parents in the nucleus of virtually every cell in our body, arranged on the 23 pairs of chromosomes that resulted when sperm fused with egg.

Our genes are a set of instructions that tell us to become a human, rather than a fish or a tree, as well as deciding what kind of a person we will be. Each gene or a combination of genes is responsible for a specific trait—from whether our baby girl will have her mother's hair and strength or her father's eye color and long fingers, to where on her body her eyes should go and how many fingers she should grow. Some genes are "dominant," always making their presence felt.

Others are "recessive" and may remain completely hidden. Between them they make each one of us physically and genetically unique.

Our parents make an equal contribution to most of our genetic make-up, but the sex of the child depends on the father. The 23rd pair of chromosomes has the specific job of determining sex. The sex chromosome that comes from the mother, in the egg, is always the same: type X. But the chromosome that comes from the father, in the sperm, could be one of two types: X for a girl, or Y, a much smaller chromosome, for a boy.

Although they won't know it for many months, an X sperm won the fertilization race for these parents, and they are going to have a girl. The genes she has inherited have already predetermined her looks and much of her character—whether she is stubborn, intelligent, a thrill-seeker, or good at music— and even her vulnerability to certain diseases like cancer, schizophrenia, and diabetes. The exact course of her life will depend on such things as her friends, her family, and her whole environment, but at the instant of fertilization much of her future is foretold.•

Molecule of life: A chromosome's DNA unwinds →

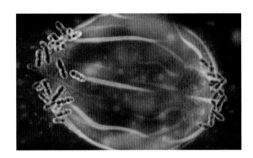

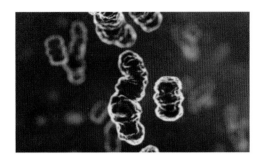

ALL IN THE MIX

All human body cells other than mature red blood cells—which have no nucleus—contain two copies of each of the 23 chromosomes (46 in total). To make sperm and eggs, the number is halved through a special kind of cell division, described in more detail on page 32.

During this process, the chromosomes lie together in their pairs and exchange chunks of their DNA sequence, a process known as recombination. Partners in each pair then move to opposite poles of the dividing cell, as shown above. In this way each chromosome in a pair is randomly assigned to one or the other of the "daughter" cells, effectively shuffling the chromosome pack.

So sperm and egg cells contain combinations of genetic material that differ not only from each other but also from those in the cells of the parents who produced them. Fertilization restores the number of chromosomes to 46 while ensuring the continued variation of the human species.

A QUESTION OF Y

In 2003 scientists mapped the entire Y chromosome and learned that most of the 78 genes on it are directly related to aspects of maleness, including sperm and testosterone production. The Y chromosome has shed 97 percent of its genes over the past 300 million years since it evolved. Those that survive have evolved a special way of "correcting" mutations, so avoiding further loss through natural selection and eventual male extinction.

Although the Y chromosome (above right) is about a sixth the size of the X chromosome (above left), Y has played an important part in allowing researchers to estimate the evolutionary age and origin of the human species. The Y chromosome doesn't exchange much genetic material with X through recombination, and because the Y chromosome is inherited solely through the male line, it can—like a surname—be used to trace back the human family tree.

Cellular powerhouse: Electronmicrograph of a mitochondrion →

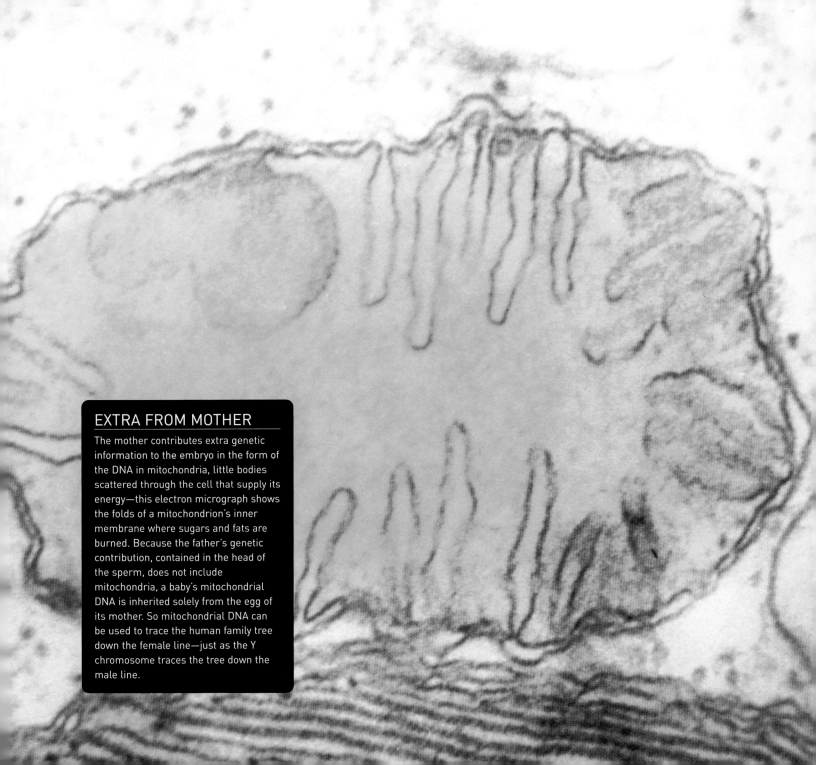

EXTRA FROM MOTHER

The mother contributes extra genetic information to the embryo in the form of the DNA in mitochondria, little bodies scattered through the cell that supply its energy—this electron micrograph shows the folds of a mitochondrion's inner membrane where sugars and fats are burned. Because the father's genetic contribution, contained in the head of the sperm, does not include mitochondria, a baby's mitochondrial DNA is inherited solely from the egg of its mother. So mitochondrial DNA can be used to trace the human family tree down the female line—just as the Y chromosome traces the tree down the male line.

THE VOYAGE BEGINS DAY 2

●

Soon after fertilization, the egg begins its journey, traveling down the Fallopian tube toward the uterus. About 30 hours later it divides for the first time. Because every cell in the body will need its own copy of the original genetic message, the chromosomes are duplicated first, making an identical copy of their DNA.

The original and duplicate chromosomes then line up across the middle of the egg on a specially formed spindlelike structure. As the fibers of this spindle contract, they draw the chromosomes apart to opposite ends of the nucleus.

When the two sets of chromosomes have separated, the nucleus splits in two, and the cell divides into two identical smaller cells containing exactly the same genetic information.

Something rather different happens when germ cells—sperm and eggs—are made in the testes and ovaries, respectively. The precursor germ cells reduce their chromosome number to half that in other cells—they go from having two sets of chromosomes to one. Two special rounds of cell division are involved. The precursor germ cell first divides to make two cells with a set of chromosomes each. Both of these cells then copy their chromosome set and divide again, so that a set of chromosomes is assigned to each of the four resulting cells.

In males, this process takes place from puberty onward and forms four sperm from each precursor germ cell. In females, it begins before birth when the fetus is only three months old,

but the first round of cell division is held in suspended animation until puberty. Shortly before ovulation, the egg completes this first round. But unlike sperm manufacture, the division is extraordinarily unequal. It results in one cell containing one set of chromosomes and most of the cellular contents and a minuscule dysfunctional cell containing the other set but little else. This so-called polar body is discarded from the main cell and soon degenerates.

Only after fertilization does the main cell go on to complete the second round of division, again packing one set of chromosomes into a polar body, which again eventually degenerates. The result is the maturation of just one large egg from each precursor germ cell. (A first polar body can be seen on page 21 as the oval-shaped body on the right of the egg.)

It is not known whether polar bodies are ever fertilized, but it has been suggested that a fertilized polar body could fuse with a fertilized egg to produce a type of chimera—a truly rare individual composed of a mixture of cells with two different genetic make-ups.

Wafting the egg: Cilia on the lining of the Fallopian tube →

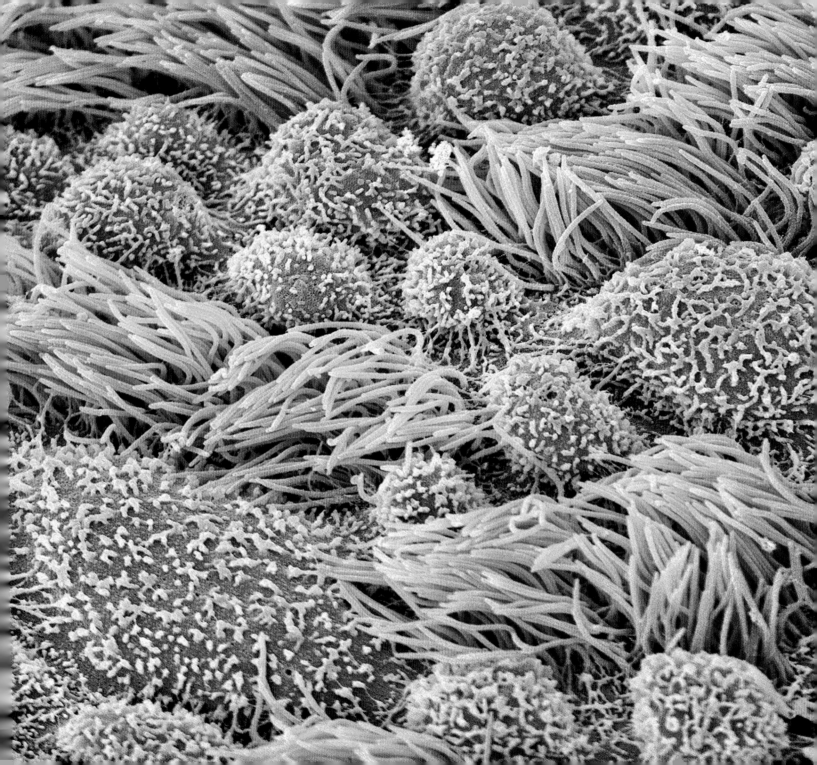

A BALL OF CELLS DAY 5

●

The process of division continues as the tiny clump of cells travels down the Fallopian tube. Because the multiplying cells depend on the nutrients stored in the egg before fertilization, they become smaller with each division, the whole cluster never growing larger than the original egg and remaining encased by the zona pellucida.

Around the eight-cell stage, the cells change shape and squash together to form a compact ball. With 12 to 15 cells, the ball resembles the fruit of the mulberry tree and is known as a morula. By the time it arrives in the uterus three or four days after fertilization it consists of 32 to 64 cells. And in the next two or three days it becomes a blastocyst, a hollow sphere filled with nutritious fluid from the uterus.

About two days after the blastocyst arrives in the uterus and just before it implants, secretions from the uterine lining cause the zona pellucida to degenerate and disappear. Until now, the zona has protected the ball of cells and prevented it from accidentally attaching to the wall of the Fallopian tube. The shedding of the zona—or "hatching of the blastocyst"—is a vital step toward successful pregnancy because it allows the blastocyst to increase in size while releasing the substances that will erode the uterine lining during implantation.

As the blastocyst enlarges, it separates into two parts. The outer layer of flattened cells, called the trophoblast, will become the placenta, whereas the clump of cells stuck on the inside of the sphere will become the embryo. These inner cells have not yet been allocated specific destinies and are known as embryonic stem cells. They have the remarkable ability to turn into any one of 350 different types of cell and can grow to become any part of the body. Cells at an earlier stage have greater potential still: Remarkably, scientists can remove a single cell from even an eight-cell embryo without harming the embryo's future development. Just how the ball of cells "knows" how many cells it contains and how far advanced they are remains an enigma.

MOTHER IN CONTROL

Until the four- or eight-cell stage, division is controlled solely by the mother's genes, or more specifically by her "messenger RNA." These molecules are temporary transcripts of the information encoded by her genes, and act outside the nucleus as go-betweens in the manufacture of proteins. Initially, the embryo uses the messenger RNA and protein that was produced while it was still an unfertilized egg in the ovary. After driving the first three or four rounds of cell division, the mother's leftover messenger RNA and protein deteriorate and the embryo has to switch on its own genes—the unique mix of the father's and the mother's DNA.

All equal: The blastocyst with cells
destined to become the embryo →

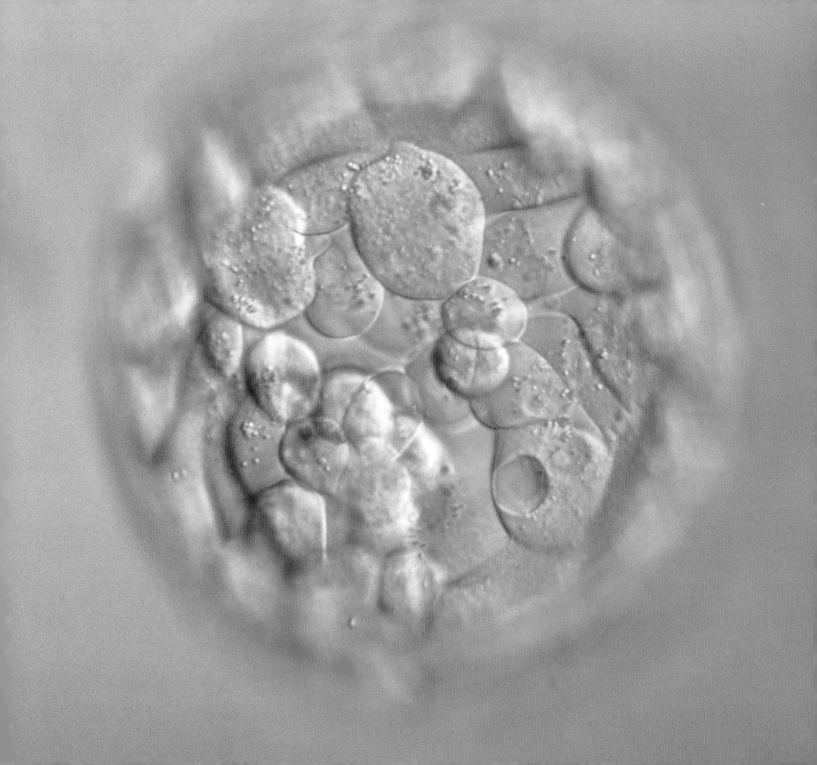

IMPLANTATION WEEK 2

By day seven, the blastocyst—now containing about a hundred cells—has dug itself into the lining of the uterus, which has been softened and swollen under the influence of progesterone. Seen magnified 4,000 times in this electron micrograph, tubular glands of the lining of the uterus produce granules of mucus that provide the blastocyst with its early source of proteins and sugars.

The blastocyst's invasion is rapid and aggressive, perpetrated by trophoblast cells that have glued themselves to the uterine lining, lost their membranes, and fused together. This united front line destroys the uterine cells by producing signaling molecules that instruct them to self-destruct and enzymes that digest their remains. At the same time, the trophoblast grows spongelike projections that erode the mother's circulation deep in the uterine wall. Her blood percolates into the resulting pores, forming the placental reservoir from which nourishment can be taken and passed along to sustain the first embryonic cells.

By day ten, the still microscopic embryo has disappeared inside the lining of the uterus, and the wound it inflicted begins to heal, the scar tissue providing it with a temporary protective capsule. The uterus must nonetheless protect itself against further incursions of what is effectively a foreign parasite. A trophoblast implanted anywhere else in the body will eat away whatever tissue it comes into contact with. In fact, scientists have discovered that it shares many of the characteristics of a malignant tumor.

Once the embryo is firmly dug in, the trophoblast starts secreting a hormone called human chorionic gonadotrophin. This is carried in the maternal blood to the ovary, where it tells the corpus luteum to continue producing progesterone. Without this hormone, the lining would break down and menstrual bleeding would begin—a catastrophe for the embryo.

The corpus luteum would normally begin to degenerate about ten days after ovulation. Because the blastocyst implants about seven days after fertilization, the trophoblast has just three or so days to "rescue" the corpus luteum and maintain progesterone secretion. It must then go on to form the embryo's life-support system, the placenta. This is why trophoblast cells are the first specialized cells the blastocyst produces, why they rapidly proliferate, making up 90 percent of its cells, and why they take root so firmly in the uterine lining.

More than a week has passed since conception, but until the mother misses a menstrual cycle she may not even realize she is pregnant. She is likely unaware that her body is creating a protected world, one that can successfully sustain a pregnancy.

Nutrient source: Granules of secreted mucus on the uterine lining →

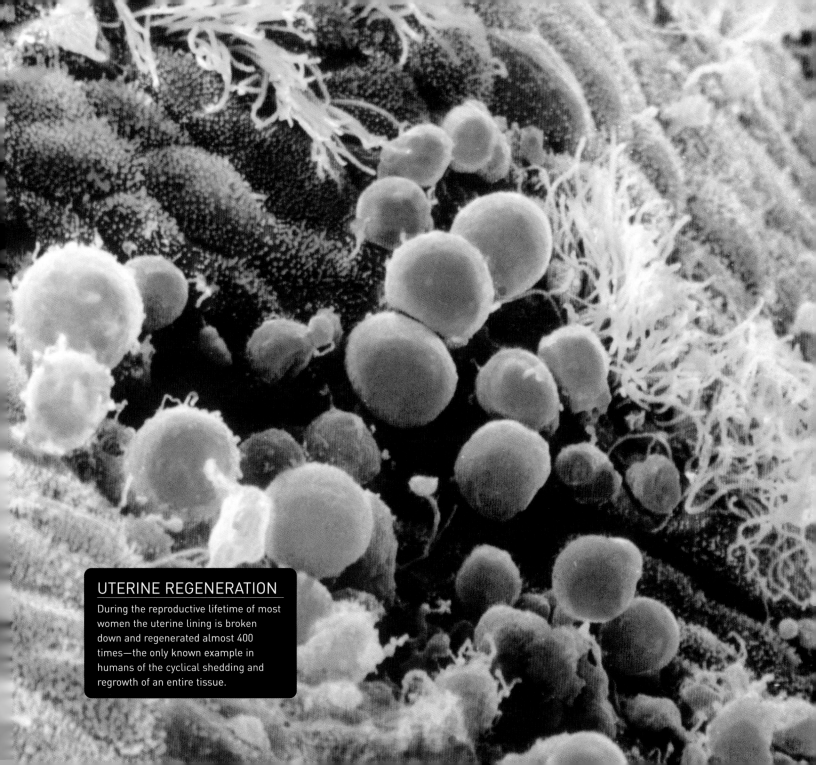

UTERINE REGENERATION

During the reproductive lifetime of most women the uterine lining is broken down and regenerated almost 400 times—the only known example in humans of the cyclical shedding and regrowth of an entire tissue.

THE VISITOR WITHIN

From the moment of fertilization the embryo is a parasite. If its circulatory system were directly connected to the mother's, the mother's body would reject the embryo. The immune system always tries to reject foreign material. Indeed, after the baby is born, if a piece of her skin is transplanted to the mother, the mother does reject it.

By contrast, the placenta is hooked up to the mother's blood supply—the trophoblasts forming it are in fact the only cells in direct contact with maternal tissues and blood. Like the embryo, the placenta inherits genes from both the father and the mother and so can be regarded by the mother's body as foreign. Yet the mother tolerates this entire foreign tissue in her system for nine whole months. Exactly what protects the placenta from rejection by the mother's immune system is one of the greatest enigmas of modern biology.

Several explanations have been suggested. One is that the mother's immune system is suppressed during pregnancy. The trouble with this explanation is that the mother can fight infections during pregnancy and will reject grafts of foreign tissues or organ transplants just as she would if not pregnant. Another possible explanation is that the immune system does not work in the uterine lining as it does in most parts of the body. In fact, there are other sites where tissue grafts can survive without rejection, such as the eye, testis, and brain. But the uterine lining rejects grafts of other genetically different tissue, and in ectopic pregnancies the embryo implants outside the uterus without being rejected.

On the basis of these findings, researchers have concluded that the ability to avoid rejection must lie with the placenta rather than the uterine lining, and gradually they are coaxing it to give up its secrets. It now appears that the mother tolerates the placenta largely because of its unique ability to subvert her immune system.

Much of the complexity of the immune system is needed to ensure it can distinguish between the body's own tissue and the cells of alien invaders: the so-called self/non-self distinction. The body distinguishes between "self" and "non-self" using a set of molecular labels called HLAs. They act as "antigens" in another person's body, provoking the production of antibodies against them. Each of us carries two sets of the six HLA genes, and there are many available variants of each—hundreds in some cases. Except in identical twins and occasionally in brothers and sisters, it is virtually impossible for any two individuals to have the same HLA combination. The genes code for protein-carbohydrate molecules that decorate the outer surface of all the body's cells.

These molecules are in effect the identity cards of an individual organism. Their central role in governing whether different tissues are compatible has earned them the name "major histocompatibility complex" or MHC (*histo* means "tissue"). They are responsible for the rejection of skin or organs surgically transplanted from one person to another, because they tell the immune system what is foreign and what is not.

The placenta seems able to pacify the mother's immune system by carefully disguising its "otherness." Unlike almost every other tissue in the body, the placenta does not have any of the usual MHC molecules on its surface. But MHC molecules have a vital role in presenting fragments of foreign material to the immune system: Infected cells serve up the fragments on MHC molecules on their surface, allowing specialized immune cells called lymphocytes to recognize the foreign material and mount an attack against invaders. So switching off the genes that make MHC proteins would appear to make the embryo vulnerable to infection.

But it turns out that the placenta has one other identity card up its sleeve: an MHC molecule found exclusively on the outer layer of fetal membranes and the trophoblast cells that burrow deep into the maternal tissues. Called MHC-G, its distribution is the complete opposite of the distribution of the usual MHCs, which are present on almost all tissues other than the placenta. What's more, the MHC-G gene does not show the tremendous variation characteristic of other MHC genes.

This means mothers have MHC-G molecules identical to those on the placenta, and so their immune system does not reject their fetuses as they would any other "transplant." Yet they can still use this exotic MHC molecule to maintain vigilance for microbes when all the usual MHC genes are switched off. MHC-G may also protect the fetus in another way. One type of immune cell dominates the maternal side of the placenta—a guard cell called a "natural killer." These cells are particularly prevalent in the uterine lining at the time of implantation, and in the first trimester are near the cells of the trophoblast, suggesting that they regulate trophoblast invasion.

Their discovery has led to the idea that MHC-G's main job may be to neutralize natural-killer cells. Like all immune guard cells, natural killers have specific targets, and natural killers home in on cells with very little MHC, usually tumor cells. They would target the trophoblast too, but MHC-G can prevent natural killer cells from attacking the placenta as if it were a tumor.

Researchers have proposed many other theories to explain how a fetus avoids rejection. They have proposed that cells of the uterine lining or the placenta produce molecules such as prostaglandins and interleukins that block or regulate the local activity of key components of the mother's immune system; that molecules on the surface of the trophoblast trigger lymphocytes to self-destruct; and that the fused trophoblast, which is in contact with the maternal blood but is coated with a fibrous material, conceals the fetal tissues from the mother's immune cells.

No single explanation suffices, and the story is far from complete. Reproductive immunology is still at the stage where questions outnumber answers. All we can say with certainty for now is that the solution to this biological puzzle is complex and subtle.•

ORGANIZATION WEEK 3

Having built itself a nest in the wall of the uterus, the embryo now needs to organize itself. At about day 13, the inner cell mass—still no bigger than a pinhead—has formed two bubbles, one inside the other. One, the early ectoderm ("outer skin"), is attached directly to the inner surface of the trophoblast and will become the amniotic cavity—the fluid-filled sac in which the embryo floats. The other bubble, the early endoderm ("inner skin"), dangles from the early ectoderm into the middle of the blastocyst and is the future yolk sac—the balloon-like structure attached to the embryo by a stalk.

The embryo starts taking shape in the disk where the two bubbles meet. This dramatic process is known as gastrulation, and it involves a mass movement of cells. At the beginning of the third week, a groove appears halfway down the length of the disk. Cells migrate toward this so-called primitive streak and pour themselves into it. The result is an embryo organized into three germ layers, the layers that will become our organs.

The top, ectoderm layer will become the outer layers of the skin, hair, nails, nipples, and tooth enamel together with the lenses of the eyes and most of the nervous system. Beneath it is the newly formed "mesoderm"—future muscle, bone and connective tissue, the heart and blood vessels, together with the reproductive organs. And at the bottom is the endoderm layer—the ultimate source of the lungs and digestive organs, including the liver, pancreas, stomach, spleen, and bowel, as well as the urinary tract and bladder.

Once the cells in the germ layers have been directed or programmed to have a specific function, they cannot change to become another type of cell. They are said to be "committed" and the process by which they go on to acquire the characteristics and functions of a particular tissue or organ is known as "differentiation."

The embryo now has the material from which to build its organs. The next stage will determine its orientation. During the third week, a rodlike structure called the notochord forms in the mesoderm—the middle layer of the embryonic disk—and dictates the position of the embryo's back. A little patch or plate of cells develops at each end—the future head and tail. Holes will be punched through all three germ layers at these sites and eventually become the baby's mouth and anus.

Just two weeks after egg met sperm, the embryo has neatly divided itself into three layers with fixed destinies, and has a top and a bottom, a front and a back, and a left and a right.

TISSUE MIX

Although the division of the germ layers into different tissues and organs may sound clear-cut, many parts of the body—teeth, breasts, arms, legs, genitalia—are in fact intricate combinations of ectoderm and mesoderm.

In position: Cells migrate to produce a three-layered embryo →

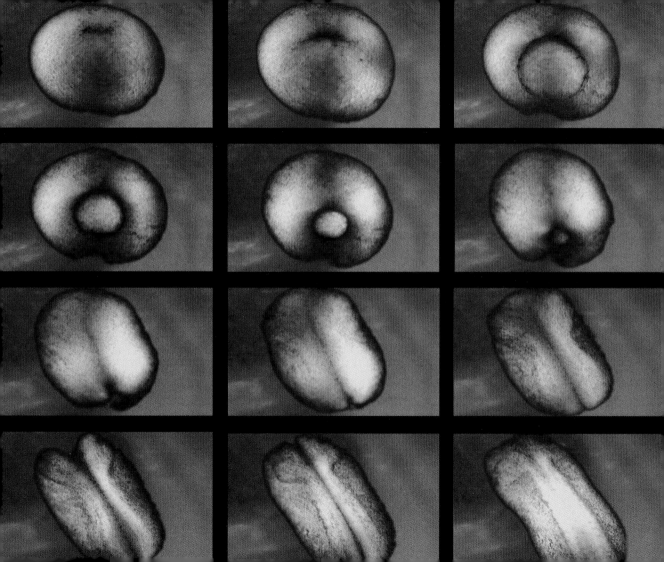

HEADS AND TAILS

How does a newly fertilized egg just thousandths of an inch wide give rise to a complex multi-billion-celled human? How do cells know where they are in the embryo and to which tissues and organs they belong? How do they create in the end a perfectly formed baby with all the bits and pieces in the right place?

Cells that start off identical in the very earliest stages of growth somehow become specialized as brain, bone, muscle, liver, or any of 350 or so types of cell in a mammalian body like ours. In genetic disorders, and in cancer too, the control of genes can go wrong. In healthy cells, appropriate genes are switched on and inappropriate ones switched off so that each plays its correct part in building the embryo.

Every cell contains the complete genetic blueprint, so there must be signals that tell descendants of the egg which of the genes to turn on, and where and when to turn them on. These cues do not come from outside but from inside the embryo itself. As the cells of the egg divide, they make daughter cells that, instead of being exact duplicates, vary slightly in which of their genes are switched on or off. Then their daughter cells do the same, and so on. Very quickly more and more new and complex structures arise, each more sophisticated and refined than the last.

The process of embryonic growth is exquisitely complicated, and there are still big gaps in our understanding. But scientists do know a lot about the messages that tell each cell which genes to turn on or off. Their discoveries amount to one of the most important achievements of modern biology.

As the fertilized egg grows into an embryo, at first it is a shapeless blob—none of its cells have specialized or "differentiated." Then gradually it develops two asymmetries: a head-tail axis and a front-back axis. In fruit flies and toads, these axes are established by the mother, whose cells instruct one end of the embryo to become the head and one part to become the back. The asymmetries are caused by gradients in the concentration of the chemical products of different maternal genes. From the strength of the local chemical signal, cells know where and what they are.

In mice and people the asymmetries develop later, and nobody knows quite how. But the triggers are almost certainly chemical. A hint of the orienting mechanism comes from a Swedish infertility clinic. Some infertile men were found to have sperm that were immotile because of a defect in special molecules needed for beating of cilia and flagella—the threads that project from the surface of cells and wave about like tiny whips. The sperm's tail is called a flagellum. These men also suffered from chronic bronchitis and sinusitis because the cilia in their respiratory tract were defective. And, strikingly, 50 percent of them had their internal organs arranged the wrong way around, or "left-right inverted," with the heart on the right.

At first the findings seemed completely mysterious. But similar effects are seen in mammals with other mutations that result

in defective cilia. This suggests that the beating of cilia somehow controls which way the left-right axis is oriented, perhaps by concentrating some signaling molecule on the left side of the embryo.

Knowing where you are is just the beginning. Knowing what you have to do once you get there is a totally different problem. Genes that control this process are known as "homeotic" genes. A cell, on discovering where it is located, acts on its own information and the signals it receives from its neighbors to switch on a gene, which switches on a gene, which switches on a gene, and so becomes, say, a liver cell or part of an arm.

In fruit flies, a set of homeotic genes organizes the various segments of the embryo. These segments have specialized roles in producing head, wings, legs, and so on. Mutations in these genes can cause flies to have legs where they should have antennae, or wings where they should have small stabilizers called halteres. After intensive study of what happens to the body plan of fruit flies exposed to chemicals that cause mutations, researchers identified the genes that together switch on different phases of early development. They discovered "gap" genes that sketch out the body plan along the head-tail axis; "pair-rule" genes that subdivide the main areas and define finer details; and "segment-polarity" genes that further subdivide these details by affecting just the front or rear of a small section. Acting hierarchically, these developmental genes package up the embryo into smaller and smaller sections to create ever more detail.

If this weren't intriguing enough, the researchers made two truly mind-boggling discoveries. First, they found a cluster of eight homeotic genes lying together on the same chromosome, which later became known as Hox genes. Surprisingly, each of the eight genes affects a different part of the fly and is lined up in the same order as the part of the fly it affects, from those affecting the head to those affecting the tail.

A second surprise was in store. Scientists found that these homeotic genes have in common a string of about 180 letters in the genetic code. In the proteins encoded by the genes, this corresponds to the bit that attaches to a strand of DNA to switch another gene on or off. Almost the same sequence, known as the homeobox, has been found in worms, frogs, mice, and humans. Amazingly, all these creatures have a similar cluster of Hox genes, with the genes laid out end to end, with the head genes first and the tail genes last.

This was a profound breakthrough. The evolutionary implication is that both humans and flies are descended from a common ancestor that used the same basic genetic mechanism for constructing bodies—a mechanism conserved over more than a thousand million years. The practical implication is that the study of fruit flies is directly relevant to human beings. In fact, the similarities between fly and human Hox genes are so close that scientists can knock out a Hox gene in a fly by deliberately mutating it, replace it with the equivalent gene from a human being, and grow a normal fly.•

A BRAIN AND SPINAL CORD WEEK 3

●

Because the nervous system coordinates the action of most of the body's other systems, it begins to form very early and continues to develop until birth and beyond. By the end of the first month, the embryo will have established the foundation of its entire nervous system. Its primitive neurons will clump together to become nerves and eventually permeate every minute region of the growing body, sending and receiving messages at up to 300 miles per hour.

On day 18 or 19, when the embryo is just 0.06 inch long, the notochord induces a change in the overlying ectoderm. The cells of the ectoderm thicken to form a sheet that starts to dip in to form a furrow that runs most of the length of the embryo's back. The two brows of the furrow then fold in toward one another, and by day 23 have zipped together and pinched off from the rest of the ectoderm sheet to form a hollow tube. This is the neural tube—the beginnings of the brain and spinal cord—and the crest of ectoderm cells left under the skin will become its neurons.

Even as the nerve cord is forming, the foundations of other organs are being built. Small bricklike blocks of tissue appear on either side of the incipient nerve cord, at first just a few, but then 10, 20, and finally 40. Made of mesoderm, these so-called somites are the first sign that humans are fundamentally "segmented" animals. Because they are so prominent during the fourth and fifth weeks, their numbers provide a reliable indicator of the embryo's age. They reach around the neural tube to meet their opposite numbers and enclose the neural

tube. They will become vertebrae and muscles and the deepest layers of the skin.

Different sections of the neural tube soon start to form the various parts of the nervous system. Even before the tube has fused, three large lobes become visible, and by the end of the third week have formed the three main parts of the brain: the hindbrain, midbrain, and forebrain. The spinal part of the tube changes the least, and in adult life the spinal cord is still a thick-walled tube with a canal down the middle.

The tubular design of the nervous system is the cause of some of the commonest birth defects in human babies. In one baby in a thousand, the neural tube fails to close and the spinal cord is left at least partly open to the outside world, causing spina bifida. There is often a failure not just of the neural tube to zip up, but also of the vertebral column to close so that the nerve cord is unprotected by bone. In its severest forms, spina bifida can result in paralysis and learning difficulties.

If the tube fails to close at the head end, then the brain cannot form, a condition known as anencephaly. Children with this abnormality are often stillborn or die within a few days of birth.

Head start: Top-down view of the embryo as the spinal cord takes shape →

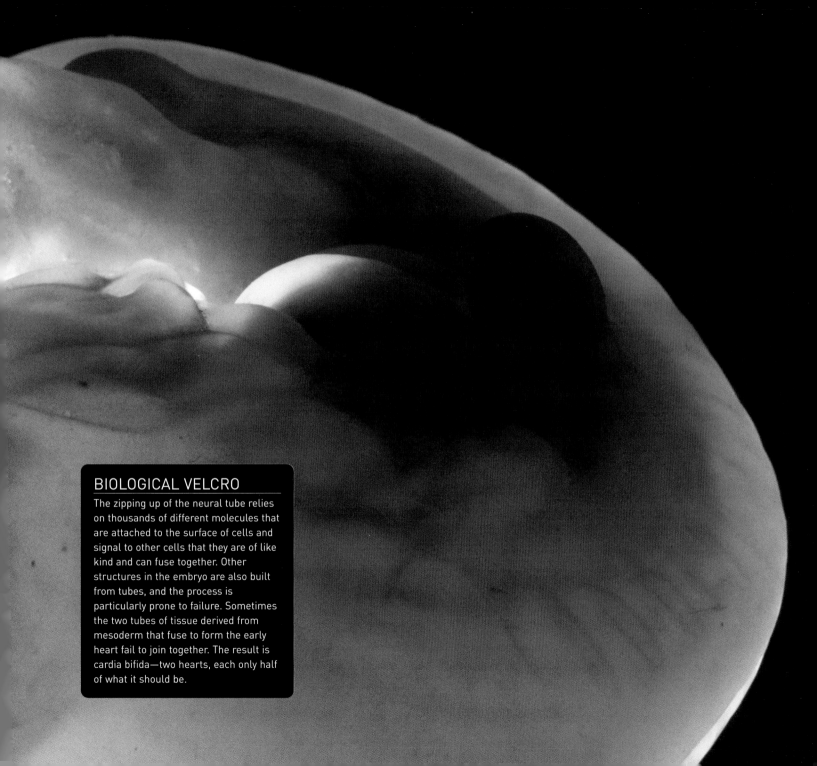

BIOLOGICAL VELCRO

The zipping up of the neural tube relies on thousands of different molecules that are attached to the surface of cells and signal to other cells that they are of like kind and can fuse together. Other structures in the embryo are also built from tubes, and the process is particularly prone to failure. Sometimes the two tubes of tissue derived from mesoderm that fuse to form the early heart fail to join together. The result is cardia bifida—two hearts, each only half of what it should be.

SIGNS OF LIFE

It is five weeks since the start of the mother's last menstrual period, and the missed period is usually her first sign that she may be pregnant. In the next five weeks some mothers may pick up on the incredible events unfolding inside them and, alerted by hormonal changes, realize they are pregnant without the aid of a test. For others, the test's thin blue line triggered by the hormone human chorionic gonadotrophin in their urine will be confirmation of the drastic changes taking place inside them.

By three months there will be a marked increase in the output of the mother's heart, and it rises further as pregnancy advances so that at birth it is up by 30 to 40 percent. Most of this rise is due to the heart beating more strongly, but the rate increases too.

The volume of blood in the mother's circulation will also increase by up to 50 percent, partly due to a thinning of the blood to allow it to pass easily through the placenta and partly to cope with the extra demand for oxygen from the parasitic growth in her womb. Once the embryo has embedded itself in the uterus, it will draw all it needs to grow from the mother's bloodstream.

What's more, it is already preparing the mother to provide it with nourishment after birth. The mother's breasts are enlarging and their surface veins are becoming more prominent. Hormonal changes are ripening the glandular tissue—the milk-secreting cells and the ducts to the nipples—leading to tenderness and tingling. Although the hormones that cause milk secretion are produced during pregnancy, lactation is suppressed until after delivery. But during the third trimester a clear liquid called colostrum may start to leak from the nipple. It is a cocktail of sugar, protein, and antibodies that will provide all the baby's nutritional needs and some protection against infection for the first few days after birth until the real milk comes through.

Other hormonally induced changes include a laxity of the joints, which may make labor and birth easier, and increased brown pigmentation of the skin. Stretch marks appear, caused by the collagen beneath the skin tearing as it stretches to accommodate the mother's expanding body. Increased blood flow to the kidneys results in increased urine production and more frequent trips to the toilet—a common symptom of early pregnancy compounded by the enlarging uterus pressing on the bladder.

The placenta produces large amounts of progesterone, which prevents the smooth muscle of the uterus from contracting but also relaxes smooth muscle throughout the body. This results in many of the so-called minor symptoms of pregnancy, such as constipation and heartburn, and it may exacerbate varicose veins. Tiredness, fainting, and a tendency to feel overemotional and tearful are also common. These symptoms seldom last more than a few weeks, but they can be aggravated and prolonged if the mother worries about them.

The mother's appetite usually increases, but her extra energy requirement for the whole pregnancy is not more than about 60,000 calories—or three weeks' worth of food. Even though the quantity of food she needs is not much increased, the quality does need attention. In particular she may need supplementary iron and vitamins.

But the most visible sign of pregnancy will be the mother's bulge. Her uterus enlarges considerably to accommodate the growing fetus. It emerges from the pelvis at around 12 weeks, reaches the navel at around 22 weeks, and the ribs at around 36 weeks.

The distension should not worry the mother at all. Under the influence of pregnancy hormones, the smooth muscle of her uterus and abdomen, through growth and stretching, can increase 60-fold in pregnancy yet return almost to its original size by six weeks after delivery.

Most women tolerate these truly remarkable changes without difficulty. Biologically, it is almost as if childbearing were the normal condition of fertile women. This view at least gets away from the idea of pregnancy as a sort of illness, and allows us instead to see many of the disagreeable symptoms associated with pregnancy as incomplete adaptations to the altered output of hormones and physical changes secondary to the growing fetus. It is the coming together of all these factors that brings about the appropriate and necessary environment for the nurturing and development of the next generation.

SURVIVAL OF THE FITTEST

Many early embryos are spontaneously aborted during the first three weeks. The early implantation stages are critical periods of development that may fail because of inadequate production of progesterone and estrogen by the corpus luteum. Tricky events are also taking place in the embryo itself, such as the cleavage of the fertilized egg, the formation of the blastocyst, and the establishment of the foundations of the entire nervous and cardiovascular systems.

Because failed embryos at this early stage are so tiny—only hundredths of an inch long—they are often lost to women who remain unaware that they have even conceived. If anything, the mother will mistake the event for delayed or particularly heavy menstrual bleeding. Although frequencies are difficult to establish, it is thought that 50 to 70 percent of pregnancies end in spontaneous abortion, with about 45 percent of pregnancies ending in the first three weeks.

More than 50 percent of all known spontaneously aborted fetuses have abnormal numbers of chromosomes—notably one extra, one too few, or a full extra set—and it is likely that many also bear harmful mutations in particular genes. In general, the chromosome abnormalities that cause early spontaneous abortions tend to be those with the most severe effects on the fetus. So early loss of embryos may have evolved to prevent females from wasting energy and endangering their own lives carrying fetuses that are severely deformed and stand little chance of long-term survival.•

FOLDING UP WEEK 4

●

The embryo now starts to look more like a human.

The flat three-layered embryonic disk, with ectoderm on top, mesoderm in the middle, and endoderm underneath, rolls up into a cylinder with an ectoderm skin on the outside and an endoderm gut tube on the inside. The space between the skin and the gut is filled by mesoderm, and within this the notochord runs from the front to the back of the embryo, above the gut. At the front of the gut is the "mouth plate" and at the back is the "anal plate." Apart from having no limbs, the embryo suddenly looks animal-shaped.

What's more, the embryo has made the rest of the key membranes in its life-support system. The endoderm bubble is left hanging like a balloon off the embryo's belly at its navel. This is the yolk sac. Although in humans there isn't actually any yolk in it, it supplies all the embryo's early needs by transferring nutrients to her until the placenta is fully developed. The yolk sac also forms part of the gut and generates primitive blood cells and germ cells—the future sperm or eggs. Behind the yolk sac is a smaller bag, the allantois, which will form the bladder and the umbilical cord.

The folding of the embryo has stretched the ectoderm bubble so that it now forms a balloon that almost entirely surrounds the embryo. This balloon is called the amniotic sac and it contains the fluid in which the fetus floats weightlessly during her time in the womb.

The yolk and amniotic sacs are suspended by a connecting stalk to the inside of a larger balloon called the chorionic sac. The outer layer of the chorionic sac—the chorion—is formed from trophoblast cells and will become the early placenta. Already little fingers of tissue called chorionic villi are sprouting and setting up access to the mother's circulation.

From blob to body: The embryo, now on its 25th day, has folded in from the sides and from top to bottom →

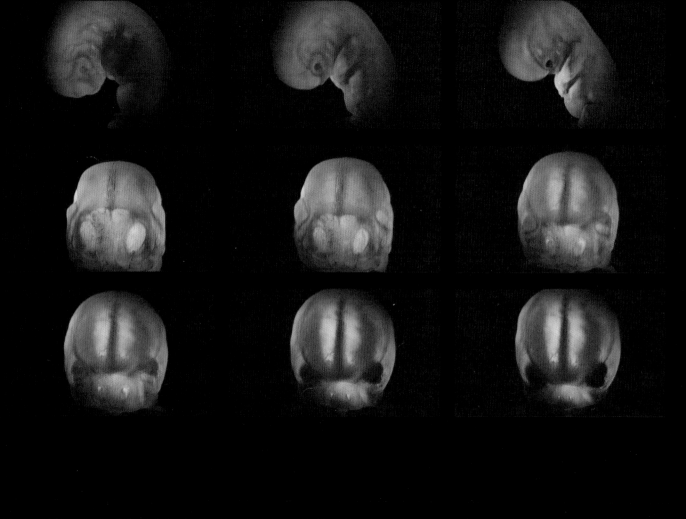

A HEART BEATS WEEK 4

●

The cardiovascular system is one of the first major systems to start working in the embryo. Without a heart and blood vessels, there is no way to deliver the food and oxygen the embryo needs to flourish. Any sustenance it once got from the egg and egg sac has long been exhausted.

Blood vessels appear at the beginning of the third week, first on the yolk sac, connecting stalk, and allantois, and two days later in the embryo itself. They are made from clusters of mesoderm cells—or "blood islands"—that hollow out and stack together.

At this stage the clump of heart cells—about the size of a poppy seed—is still. Arranged initially as a pair of crescent-shaped tracts, these fuse to form a single S-shaped tube, which is plumbed into blood vessels in the embryo, yolk sac, chorion, and connecting stalk to form a basic cardiovascular system. On day 22 or 23, at the start of week 4, single heart cell jolts into life. This tiny movement sparks a chain reaction, and other cells in the cluster pick up the rhythm. The new cells divide, dance to the same beat, and eventually grow into the baby's four-chambered heart.

The muscle cells of the heart are preprogrammed to contract. Incredibly, the contraction is perfectly coordinated so that the upper part of the heart starts squeezing just as the lower part begins to expand. Later on, when the nervous system is more developed, the brain will control the rate of contraction, keeping the heart steadily beating and pumping for the rest of the person's life. If she lives to 75, that will be nearly three billion heartbeats.

By the end of the week, with the heart pumping rhythmically, primitive blood cells start to circulate in the fetus through vessels no thicker than a hair. The blood cells bring vital supplies of oxygen and nutrients from the placenta to fuel her phenomenal growth over the next eight months.

New vessels: A vein and an artery, carrying blood to and from the heart, respectively →

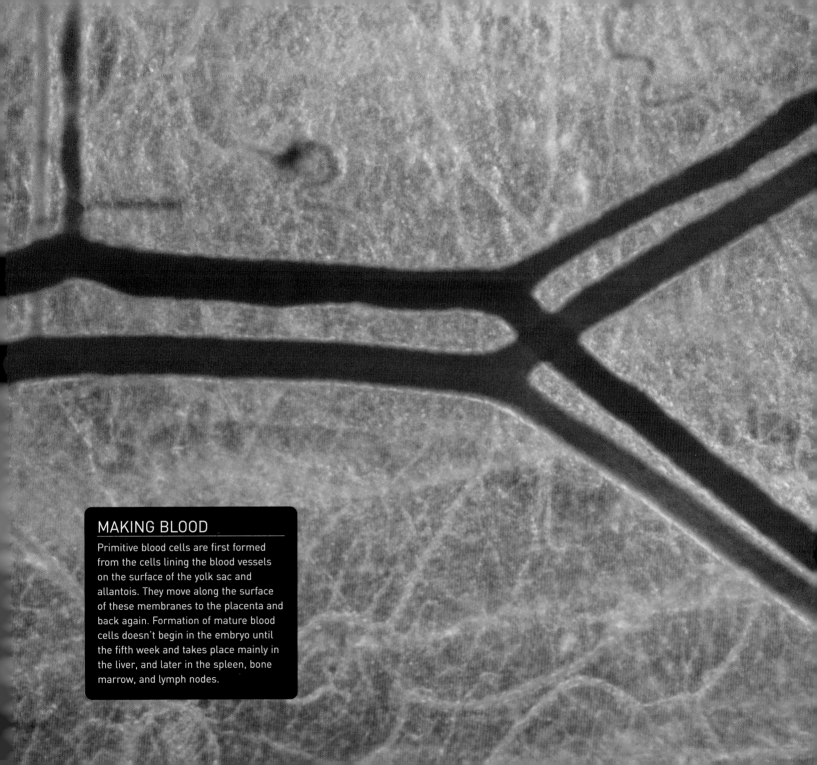

MAKING BLOOD

Primitive blood cells are first formed
from the cells lining the blood vessels
on the surface of the yolk sac and
allantois. They move along the surface
of these membranes to the placenta and
back again. Formation of mature blood
cells doesn't begin in the embryo until
the fifth week and takes place mainly in
the liver, and later in the spleen, bone
marrow, and lymph nodes.

BODYBUILDING WEEK 4

●

Day 28 and the embryo is growing about 0.04 inch a day and is still no bigger than the head of a match, yet all her vital organs are already mapped out.

She curls forward into a characteristic C shape, with a long, curved tail. The back of her head is growing faster than the front, and her forebrain is a prominent bump. Building blocks are in place for the inner ear—the internal labyrinth that has a role in both hearing and balance. Black bubbles are the beginnings of the lenses of the eyes. They will come to lie suspended across the mouth of a cuplike structure on a stalk that is growing out from the brain. Much of the cup becomes the light-sensitive retina, but the lip becomes a circular ring of colored muscle, the iris, that partially covers the lens. The stalk becomes the optic tract, and this soon starts to carry visual information from the retina to the brain.

Emerging buds on the sides of her body will grow into arms and legs. Her miniature heart, which bulges out from her midriff, beats 80 times a minute and is getting faster every day. As a proportion of her total body size, it is nine times as large as an adult's heart, the extra power being needed to force the blood around the umbilical cord and placenta as well as around the embryo's body.

At her head end, five gill-like folds are visible, which will create her face and jaw. The top fold will grow down to make her forehead and nose, the two lower folds will meet to form her lower jaw and lower lip, and the two side folds will grow in to form her cheeks and top lip. Even in adulthood we bear a clear mark from the meeting of the cheek folds: the vertical groove between the mouth and nose called the philtrum. If the sides don't join up properly, the baby will develop a cleft palate and may need corrective surgery after birth.

Although not yet working properly, a basic tubular digestive tract has grown downward from the mouth, which now opens. There is a stomach, a liver, a gall bladder, a pancreas, and a thyroid gland but no anal opening. The rudiments of the lungs start to appear, though they are still connected to the gut. And amoeba-like primitive germ cells—the future sperm or eggs—form in the wall of the yolk sac.

For now, though, even an expert would find it difficult to tell just from looking at it whether this embryo is going to become a human, a pig, or an ape—let alone a boy or a girl. Just 1.5 percent of our DNA makes us human: We share 98.5 percent of our DNA sequence with our closest relative, chimpanzees, 75 percent with dogs, 50 percent with fruit flies, and 33 percent with daffodils.

But over the next four weeks our embryo will continue to grow according to her own internal genetic instructions. All her major organs and systems will begin to take shape, and she will start to look distinctly human.

Big heart: 4-week embryo →

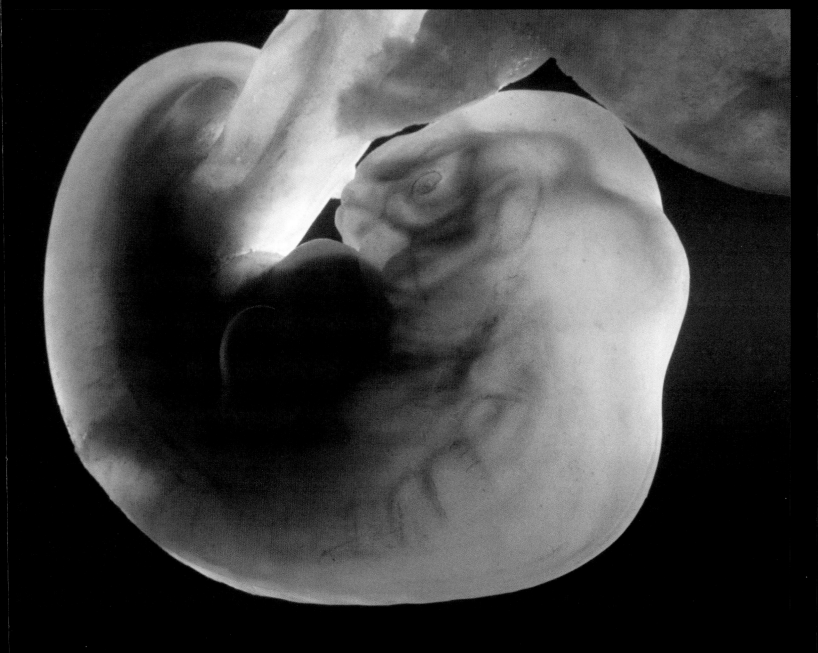

GESTATION: 04 weeks | LENGTH: 0.2 inch

HEAD START WEEK 6

●

The embryo has been growing now for six weeks. She is just a half-inch long—about the size of a kidney bean.

Her arm buds look paddle shaped; her leg buds flipperlike. Plates of cells have sprung up that will become her hands and feet. Just black dots a few days ago, her eyes have grown. Set widely apart, they are glassy, sightless, black-rimmed domes with no eyelids or irises. The retinas contain some pigment, the lens disks are in place, and the muscles—among the body's most delicate—have started to form. The embryo's nose and mouth are also recognizable, and tiny mounds of tissue erupt where the whorl of the external ear will grow. Nerve fibers connect with the olfactory region of the brain, paving the way for the sense of smell.

Her brain is now a series of five cavities lined with embryonic nerve tissue that will grow to almost fill them. Rudiments of the cerebral cortex—the part of the brain responsible for the intellect and that controls voluntary movement—can be seen. Because of the rapid growth of both the brain and the face, the head is still massively outgrowing her body. The embryo seems to be nodding at the bulge of her heart, which has begun to develop valves and compartments.

The liver has taken over the manufacture of blood cells from the yolk sac, which is now separated from the digestive tract by its attenuated stalk. The kidneys are in place but not yet filtering waste. The lungs are lobed and dividing into segments containing a filigree of branched tubes. Ridges for external genitals have appeared, and the primitive germ cells migrate up the yolk sac, through the navel, past the gut, before finally turning sideways into the developing sex glands, or "gonads"— the future testes or ovaries. For now, though, male and female embryos look exactly the same.

EVOLUTIONARY VESTIGES
The embryo goes through two pairs of kidneys before acquiring the definitive pair. The first kidneys appear in the fourth week and are similar to those found in primitive eels. They are rudimentary and do not function. The second set appears late in the fourth week and is froglike. These kidneys are well developed and filter the blood for much of the second month. The third set begins to develop early in the fifth week and takes over from the second set about four weeks later. Unmistakably human looking, these kidneys must last a lifetime. A vestige of our ancestry, this transition reveals the similarity between the embryonic development of a human and that of other vertebrates.

EARLIEST REFLEXES

It has been reported that embryos in the sixth week show spontaneous movements such as twitching of the trunk and limbs and reflex responses to touch. These first reflexes are "total": That is, the body reacts equally to any and every type of stimulus.

Legs and arms: 6-week embryo →

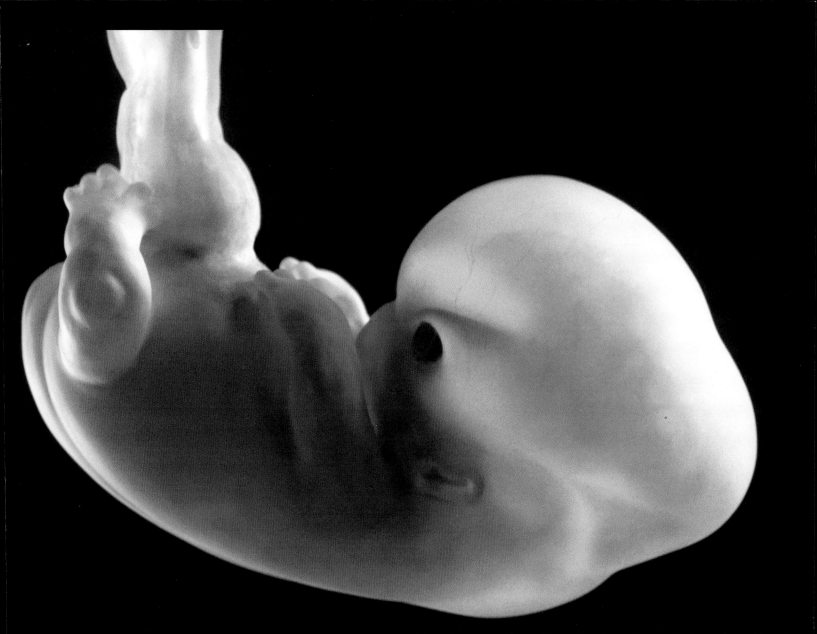

A HUMAN FACE WEEKS 7 AND 8
●

The past five weeks have seen the most dramatic transformation of the entire pregnancy. The embryo has made hundreds of different types of cells, her muscles and nerves are twitching, and she has all her major organs and body systems in place. In the process she has metamorphosed from a nubbin no bigger than a grain of rice into a distinctly human being who would only just fit inside a walnut shell.

The embryo now has distinct human characteristics, but her head is still disproportionately large, making up half her crown-rump length. Her hands and feet approach each other in front of her body. Her ears are nearing their final shape, though they are still set low on her head. The tip of her nose is distinct, and the nasal passages are open to the outside.

The light-sensitive cells of the retina have formed, and nerve connections from the retina to the brain have been established. Her eyelids are now more obvious as gluey ridges at the edges of the eyes, which are about to seal shut to protect them in the final, delicate stages of their formation. They won't open again until 25 or 26 weeks, when the neurons of the visual cortex are in place.

Inside her mouth is a palate and tiny tongue that already has taste buds. Tooth buds for all 20 milk teeth are in place in the developing jawbone. Nipples are visible. Although there are now sex differences in the appearance of the external genitals, they are still not distinctive enough to tell with any certainty whether our embryo is a girl or a boy.

Now separated from the heart and lungs by the diaphragm, the intestines are growing so fast that some of the loops they form protrude for a time through the embryo's abdominal wall, where they continue to develop in a sac next to the umbilical cord. The stomach is a miniature version of what it will be in the newborn baby, although for now it is blocked where it joins the small intestine. At the far end of the digestive tract the anal opening has ruptured through the membrane of the rectum.

STRETCHING OUT

By the eighth week the muscles and nervous system have started to become interconnected and integrated, with the embryo making its first purposeful movements.

Familiar features: 8-week embryo →

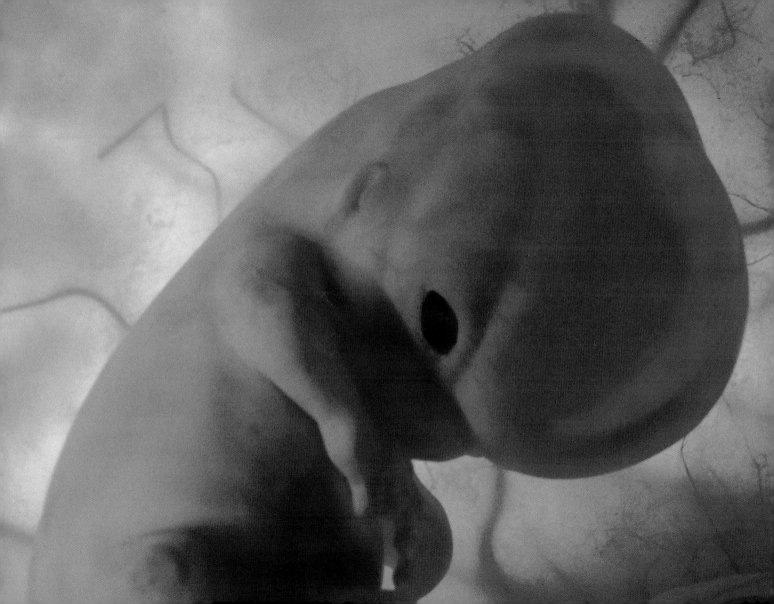

CELL DEATH BY DESIGN

As the baby's limbs take shape and lengthen, the folds of skin making up the limb buds start to condense and form cartilage, which will later develop into hard bones. The cartilage serves only as a mold, with the bone cells invading and displacing it. By the end of the eighth week, the webbed hands and feet have developed separate digits, and shoulders and elbows have appeared.

The baby makes her fingers and toes by getting rid of superfluous web tissue between them, much as a sculptor would do. The process is actually a precisely timed mass suicide. Chemical messages from outside the cells between the future digits command them to self-destruct. Special enzymes called caspases are activated inside the cells and bring about cellular meltdown.

This mechanism is also responsible for the formation of tubular structures such as the windpipe and parts of the gut. The brain is sculpted in a similar but subtler fashion, by the creation of too many cells and the elimination of those that don't fit the required patterns of interconnections. Suicide seems to be part of the developmental deal: death programmed as a tool of life.

Programmed cell death helps to keep the number of cells in an organ or tissue within certain limits. Blood and skin cells, for instance, are constantly renewed by progenitor cells, but this proliferation has to be balanced by cell death. Some 50–70 billion cells die each day owing to programmed cell death in the average human adult. In a year, this amounts to the proliferation and subsequent destruction of a mass of cells equal to an individual's body weight.

In addition to its importance in normal biological processes, programmed cell death is implicated in an extensive variety of human diseases. Too much programmed cell death causes cell-loss diseases such as micromelia, a condition in which the limbs are shortened. If a cell's capability for programmed cell death is damaged (for example, by mutation) or the process is blocked (for example, by a virus), then a damaged cell can continue dividing without restrictions, resulting in cancerous tumors.•

Digital sculpture: Deepening notches separate the future fingers →

FROM EMBRYO TO FETUS

After growing for eight weeks, the embryo, a Greek word meaning "swell," becomes known as a fetus, which in Latin means "offspring." She has passed two important milestones. First, because most of her essential external and internal structures were formed during the past four weeks, she has survived the most critical period of her development—a period when the embryo is particularly vulnerable to agents such as viruses or drugs that can give rise to birth defects by interfering with the formation of tissues or organs.

Second, she has until now been dependent on the nutrients she could extract from her yolk sac, the floating balloon connected to the base of her umbilical cord that for the first few weeks supplies nutrients and blood cells to the tiny embryo. By two months the yolk sac becomes redundant and shrivels away. The crucial job of nurturing the fetus is now completely taken over by the placenta. It provides nutrients and oxygen and filters out carbon dioxide and other waste.

In transition: The embryo with her rapidly depleting yolk sac (left) →

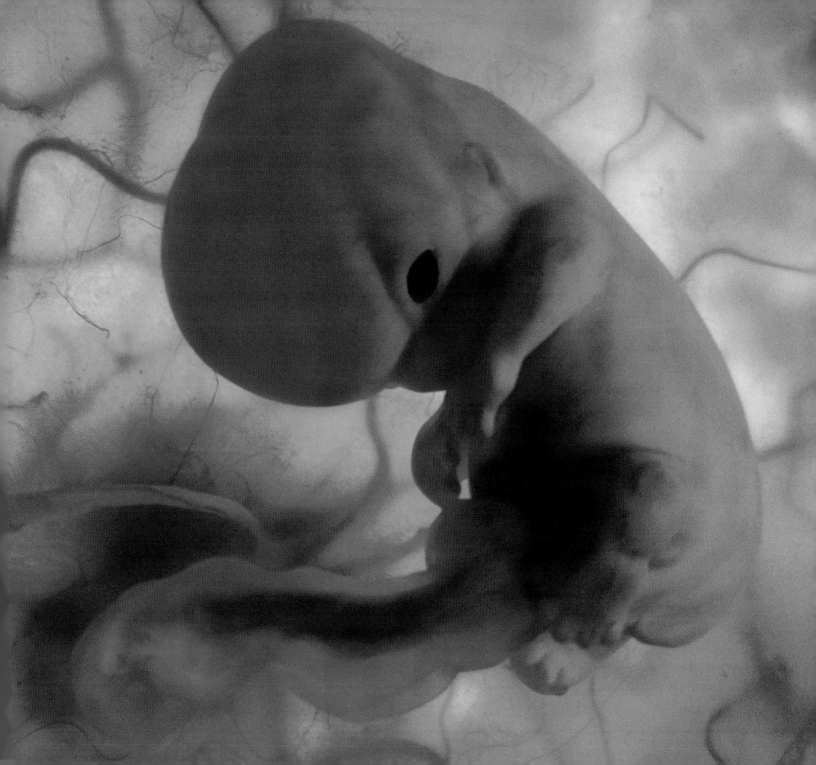

THE PLACENTA

The placenta will be the fetus's life-support system for the rest of her time in the womb. Latin for "circular cake," it resembles a spongy, pizza-shaped liver. It may not be beautiful, but it is one of nature's most underappreciated inventions.

It consists of a tree of exquisitely fine blood vessels running through a network of chorionic villi, most of which float in a reservoir of maternal blood. The reservoir fills the so-called intervillous space, which was carved out by the spongelike extensions of the fused trophoblast as it invaded the uterine lining. The chorionic villi projecting into the intervillous space are more recent extensions of the backup trophoblast cells of the chorion. The longest branches of chorionic villi anchor the chorion to the fibrous tissue deep under the uterine lining.

Like the roots of a tree sucking nutrients from the soil, the blood vessels of the chorionic villi extract everything the fetus needs from the mother's blood—food, oxygen, water. With each beat of the mother's heart, blood from around a hundred uterine arteries spurts into the intervillous space like a fountain. The blood bathes the chorionic villi before seeping away through the mother's veins.

Embryonic blood begins to flow through the minute vessels in the chorionic villi by the end of the third week, and the mother's blood first begins to permeate the intervillous space a week later. In the first trimester, the placenta grows more rapidly than the fetus, but by the 15th week it is about the same weight as the fetus, and at birth roughly a sixth of the fetus's weight—some six inches across and weighing about a pound. Up to 35 percent of the mother's blood flow courses through the placenta.

The large number of blood vessels in the chorionic villi and the relatively sluggish flow of the mother's blood through the intervillous space give plenty of opportunity for oxygen and nutrients to pass into the fetus's circulation. At the same time, carbon dioxide and other waste products from the fetus are dumped into the intervillous space and are carried away in the mother's blood.

Despite their closeness, there is no direct connection between the two sets of blood vessels in the placenta, one going to and from the mother, the other going to and from the fetus. The circulations of the mother and fetus are side by side, but they never mix. They are separated by a thin membrane that envelops the chorionic villi. This means that any bleeding in pregnancy is likely to originate from the pool of maternal blood, not from the fetus. The fetal circulation is protected, even if the placenta is damaged. If the fetal and maternal circulations did mix, the mother's immune system would launch a formidable attack on the fetus, ending the pregnancy.

But the placental membrane and vessels are permeable, and an exchange of ingredients—oxygen, dissolved food, waste, and

Deep roots: Villi surfaces (green) opened up to reveal fetal blood vessels (purple) →

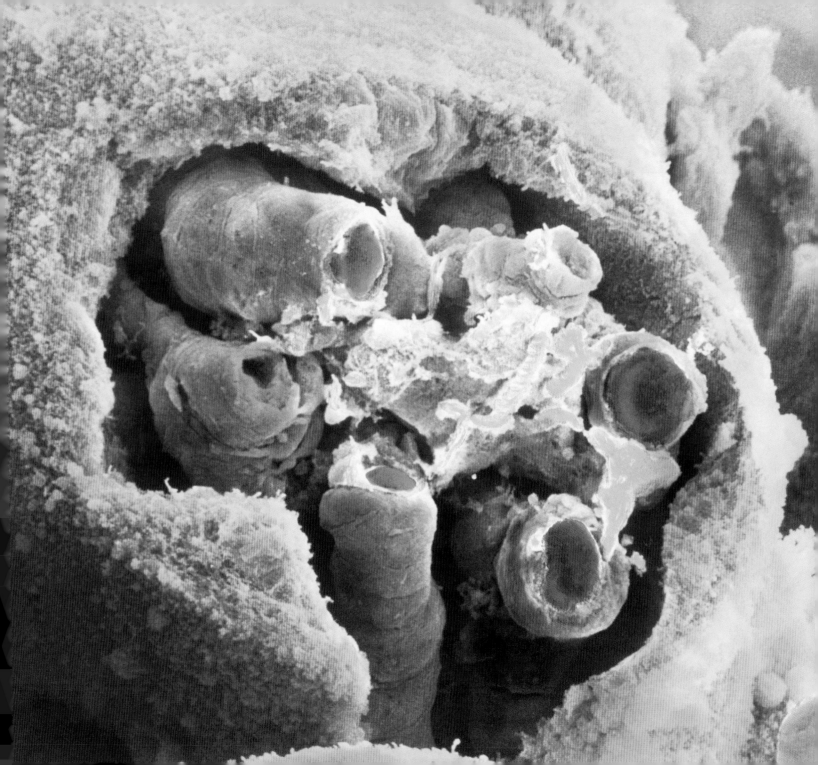

so on—is constantly taking place through their walls. The placenta is so efficient that within an hour or two after the mother has a meal the fetus gets some too. Molecules that are too large have difficulty passing through, so the membrane filters out harmful substances and infectious agents that may be in the mother's bloodstream and could damage the fetus.

But it can't stop smaller harmful molecules, and so the mother has to be careful with things like prescription drugs, alcohol, and nicotine that would pass directly to the fetus. Viruses such as cytomegalovirus (a herpes virus), rubella, smallpox, measles, and poliomyelitis, as well as microorganisms that cause syphilis and toxoplasmosis, can also pass through the placental membrane—often with devastating effects.

The mother bestows some immunity on the fetus by the transfer across the placental membrane of antibodies—proteins designed to attach to infectious organisms and render them harmless. Antibodies that confer immunity to diseases such as diphtheria, smallpox, and measles reach the fetus and protect her for weeks after birth, though she doesn't acquire any immunity to whooping cough or chickenpox. After birth, she continues to receive antibodies from breast milk, giving her protection for the first few months until she is capable of producing her own.

The first trimester can be an uncomfortable time for the mother. As well as being an organ of respiration, nutrition and excretion for the fetus, the placenta acts as an endocrine gland, secreting hormones that diffuse into the mother's circulation and help her to maintain the pregnancy and prepare her for birth and breastfeeding. Early on in the pregnancy these hormones will give some women morning sickness. One of them, progesterone, is secreted throughout the term and prevents the mother from releasing more eggs. Others may prevent the mother's immune system from rejecting the unfamiliar growth inside her.

CHORIONIC VILLUS SAMPLING
Chorionic villus sampling, or CVS, is a prenatal diagnostic test for fetal genetic abnormalities. Usually performed at 11 to 13 weeks, it involves taking a small sample of cells from the chorionic villi. These cells originate from the trophoblast, so they contain the same genetic information as cells from the fetus. The procedure can identify conditions such as Down syndrome, cystic fibrosis, Tay-Sachs disease, sickle cell anemia, and thalassemia.

About one percent of women who undergo CVS miscarry. The risk of miscarriage seems to be slightly higher after CVS than after amniocentesis, but this may be because CVS tends to be performed earlier in pregnancy, when the fetus is more likely to miscarry anyway. There is also evidence that when CVS is done before ten weeks, the baby may develop limb defects.•

**Blood basics: Fetal red cells yet to assume
the adult hollowed disk shape →**

FETAL HEMOGLOBIN

The fetus increases her oxygen intake by using a special type of hemoglobin, the oxygen-carrying molecule found in red blood cells. Fetal hemoglobin has a greater affinity for oxygen than does adult hemoglobin, so fetal blood can wrest oxygen from maternal blood in the placenta and transport it to the fetal tissues more efficiently. The proportion of fetal hemoglobin slowly declines during pregnancy as adult hemoglobin begins to take over, so that at birth it makes up around 60 percent of the total.

CROSSING THE BORDER

In places the placental membrane is no more than one cell thick, and fetal blood cells do sometimes leak into the mother's circulation through microscopic breaks. As many as 1 in 100,000 cells in the mother's blood may be of fetal origin, and the proportion is higher for fetuses with chromosomal abnormalities. These cells can persist in the mother's bloodstream for decades after the baby is born. If attacked by the mother's immune system, they can cause inflammation and lead to autoimmune disease. But in most cases the mother probably gets used to them.

Researchers have found male fetal stem cells lodged in women's bone marrow more than 50 years after the women gave birth to boys. This may explain why marrow transplants from a mother to a child are less likely to be rejected than those from a father: Persisting fetal cells may make the graft seem less foreign to the child. Some scientists argue that fetal stem cells might be capable of replacing the mother's aging cells and restoring damaged tissue. It has even been suggested that this is why women tend to live longer than men and why pregnancy seems to provide mothers with protection against diseases such as multiple sclerosis and breast cancer.

The presence of fetal cells in the blood of pregnant women offers the opportunity to develop a noninvasive—and risk-free—prenatal diagnostic test. Modern methods are sensitive enough to detect these stray cells and examine their genes. The sex of human babies can be established from fetal cells collected from maternal blood, and soon we may be able to diagnose genetic diseases from blood from pregnant women.

DELIVERY SERVICE

Oxygen, water, and nutrients pass freely to the fetus from the mother through the placenta. Most nutrients such as salts, fats, and fat-soluble vitamins (A, D, and E) can usually get across the placenta by simple diffusion, passively spreading from the high concentrations in the mother's blood to the low concentrations in the baby's blood.

But glucose, a primary source of energy, doesn't pass across the placenta very quickly, so special molecules built into the membranes of the placental cells bind to glucose and help to move it from one side to the other. Insulin, needed to regulate the metabolism of glucose, is also unable to cross the placenta, so comes not from the mother but from the fetal pancreas. Insulin-containing granules are seen in the fetal pancreas by 10 weeks, and insulin is detectable in the bloodstream at 12 weeks.

Some substances such as amino acids—the building blocks of proteins—and the water-soluble vitamins B and C are reluctant to cross the placenta because it entails going from a low concentration to a higher one, while others such as calcium, iron, and iodine require careful handling. Molecules in the placental membrane help to pump these nutrients into the fetal circulation.•

In store: Insulin-secreting granules in a pancreatic cell →

THE UMBILICAL CORD

The placenta supplies the embryo with all its needs, carries away its wastes, and protects it from harmful invaders. It does all this via the baby's lifeline, the umbilical cord.

When the embryo first embeds itself in the lining of the uterus it is small enough for adequate amounts of dissolved gases, nutrients, and waste to be exchanged across its surface. Then, as part of very early growth and reshaping, a short stalk—the connecting stalk—is formed out of its own tissue. Loops of blood vessels grow into this stalk when the embryo's heart and circulation develop. The stalk lengthens as the fetus grows within its amniotic sac, and at the uterine end the blood vessels become part of the developing placenta.

In this way the fetus grows its own umbilical cord, containing its own blood vessels: a single large vein that carries oxygen-rich blood and nutrients from the uterus to the fetus via the placenta, and two small arteries that transport waste products and oxygen-depleted blood from the fetus back to the mother for recharging.

As these three vessels grow they form intertwining spirals and become embedded in a simple "jelly" with a thick protective outer covering, so that the mature cord resembles a twisted rope. A counterclockwise twist is more common than a clockwise twist. By full term the cord is about 22 inches long, looped within the amniotic sac, allowing the mature fetus to move around freely. Because the three vessels are coiled like a spring and the blood is rushing through them at about four miles per hour, they are fairly resistant to being squashed and the cord tends to straighten when bent. It contains no other blood vessels and no nerves.

Twisting and bending of the umbilical vessels are common because the vessels are longer than the cord itself. They often form loops, producing false knots that are not dangerous for the baby. But in about 1 in 100 pregnancies, true knots form in the actual cord. These may tighten and cause the fetus respiratory distress. In most cases, the knots form during labor as a result of the fetus passing through a loop of the cord. Because these knots are usually loose, they are no cause for concern. In about a fifth of all safe deliveries, the cord is loosely looped around the neck.

STEM CELL SUPPLY

Blood retrieved from the umbilical cord after the birth is a rich source of blood stem cells. These can produce all other blood components, including blood-clotting platelets and red and white blood cells. Like donated bone marrow, umbilical cord blood can be used to treat various genetic disorders that affect the blood and immune system, cancers such as leukemia, and some inherited disorders of body chemistry.•

Lifeline: Ultrasound scans showing the umbilical vein (blue) and arteries (red) →

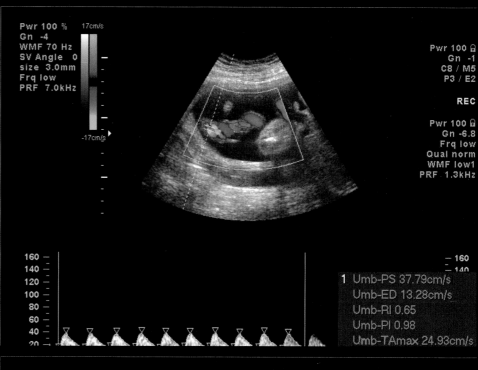

Pwr 100 %
Gn -4
WMF 70 Hz
SV Angle 0
size 3.0mm
Frq low
PRF 7.0kHz

17cm/s

-17cm/s

Pwr 100
Gn -1
C8 / M5
P3 / E2

REC

Pwr 100
Gn -6.8
Frq low
Qual norm
WMF low1
PRF 1.3kHz

160
140
120
100
80
60
40
20

160
140

1 Umb-PS 37.79cm/s
Umb-ED 13.28cm/s
Umb-RI 0.65
Umb-PI 0.98
Umb-TAmax 24.93cm/s

CORD BLOOD SAMPLING

Abnormalities in cord position or structure can be detected by "Doppler ultrasound," which measures blood flow in the cord. As early as 16 weeks after conception, when the vessels are large enough to be seen clearly by ultrasound, blood can be removed from the umbilical cord and used to diagnose inherited blood disorders, detect infections, and assess fetal anemia. The procedure has a risk of miscarriage of 1 to 2 percent.

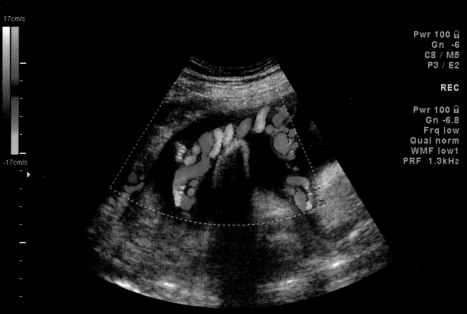

17cm/s

-17cm/s

Pwr 100
Gn -6
C8 / M5
P3 / E2

REC

Pwr 100
Gn -6.8
Frq low
Qual norm
WMF low1
PRF 1.3kHz

DARWINIAN SICKNESS?

About two-thirds of women are troubled by nausea with or without vomiting in early pregnancy. Although the condition is traditionally referred to as morning sickness because the problem often hits women particularly badly when they get up in the morning and eat their first meal of the day, symptoms can strike in the afternoon, evening, or throughout the day. It usually stops at around week 14 of pregnancy, but in 10 percent of women persists to week 20.

Although commonly attributed to high levels of human chorionic gonadotropin in the mother's bloodstream, the exact cause of morning sickness is still not fully understood. Scientists have proposed many plausible theories, but so far research has proved inconclusive. The hormonal theory falls down because nausea doesn't always lift as levels of human chorionic gonadotropin decrease. Nor does morning sickness seem to reflect emotional factors such as ambivalence toward or unconscious rejection of the pregnancy. Although more than half of affected women report dramatic improvements in their condition when given a placebo, it is unaffected women who have psychological difficulties during pregnancy and who are less likely to breastfeed.

One of the more intriguing suggestions is that morning sickness may have evolved as an adaptation that protects the baby. Combined with strange food cravings and aversions, it might just be nature's way of shielding both the mother and her fetus from foodborne illnesses or the fetus from toxins that could harm vulnerable organs at a critical time in development.

Both morning sickness and fetal organ development peak at about the same time, usually two to eight weeks after conception, and it is known that fetal exposure to drugs and viruses during this period can cause serious birth defects. At a time when the mother's immune system is naturally compromised to prevent it from attacking the fetus, morning sickness may be acting as a backup defense mechanism.

Some pregnant mothers instinctively avoid food or drink that could be harmful to the fetus. They may be revolted by the smell of alcohol or seafood or mushrooms. It is as if the mother's body is dictating her intake of food, telling her what to avoid and what to crave to ensure her fetus gets what it needs.

Pregnant women are notorious for their diverse and sometimes bizarre food tastes. Some prefer blander foods, while others prefer salty or spicy dishes. Many pregnant women crave sweets, dairy products, and sour fruits. They may crave salt because of a mineral shortage brought about by the increases in their blood volume and body fluids. They may crave sugar because they need a quick boost of energy. (Nausea has been linked to low blood sugar levels because it often occurs first thing in the morning after many hours without food or at the end of the day when the mother is likely to be tired and in need of rest or food.) Some women can't stand the smell or taste of bitter, strong-tasting vegetables or tea or coffee, and many report aversions to meat, poultry, fish, and eggs—foods more likely to contain parasites or other pathogens if not refrigerated properly. A study of 20 societies in

which women experience morning sickness and 7 in which morning sickness is rare found that the latter were more likely to have plants (such as corn) as the primary staple than animal products.

Food contains olfactory cues that alert a woman's body to potential dangers. A piece of rotten meat or carton of sour milk, for example, lets our noses know that bacteria have contaminated the food and are producing harmful substances that will probably make us sick. Pregnant women have a strong aversion to vegetables and meat, which spoil quickly, and little or no aversion to bread and cereals, which do not.

Around 20 percent of pregnant women become more sensitive to odors during the first few weeks of pregnancy. This could be linked to changes in a woman's hormonal system. The intensity of this experience can trigger nausea and vomiting and further increase her aversion to particular foods or substances.

Plants manufacture bitter-tasting toxins to ward off their natural predators. The amount of toxins in these foods is very low, and normally humans can tolerate them, but they could have detrimental effects on a developing embryo. Drinks such as whiskey and wine that contain plant derivatives tend to be more repulsive to pregnant women than drinks that do not contain plant extracts, though the aversion to alcohol in general is not as strong as that to food. This could be because ethanol, the main component of alcohol, doesn't taste particularly bitter.

Yet puzzles remain. In a rare condition known as couvades syndrome a man can suffer from morning sickness and share other symptoms of pregnancy with his partner such as weight gain, fatigue, frequent trips to the bathroom, and even stomach cramps while she is in labor. A woman may suffer terrible nausea and vomiting during one pregnancy, but none in another. And the children of mothers who suffer severe morning sickness are more likely to prefer salty foods later in life—perhaps the hormones that signal the need to replenish minerals after vomiting can somehow program the developing baby's taste preferences.

What we do know is that women who experience morning sickness in the first trimester are less likely to miscarry than women who do not. What's more, women who vomit are much less likely to miscarry than those who have nausea alone. On the other hand, pregnant women who do not have morning sickness need not worry. A lack of morning sickness does not mean that the pregnancy will fail any more than constant vomiting will guarantee a positive outcome. Nor will the outcome be improved by persuading a pregnant woman to eat foods she can't stand.

The Greek physician Soranus described accurately the time-span of morning sickness in the second century A.D. and he advised giving "little and easily digestible food...and not some very fat fowl." This advice would seem to hold well today.●

GROWTH SPURT WEEKS 9–12

The fetus's body is rapidly catching up with her head in terms of growth, and within four weeks her crown-rump length has doubled. She loses her earlier comma-like shape as her pointed tail recedes into her body. A neck appears as her back straightens and lifts her chin off her chest. Her face is broad with widely set eyes, fused lids, and low-set ears. Buds for the permanent teeth begin to form under the gums. Toward the end of the 12th week the first hairs start to appear—fine, soft, and lightly pigmented "lanugo" (Latin for "downy hair"). Fingernails start to develop. Her arms reach their final relative length, though her legs are still proportionally short, with notably small thighs.

Her intestines have moved back from the umbilical cord to the abdomen and bulge less. At 9 weeks the liver is the major site of the formation of red blood cells, but by week 12 the activity has wound down there and begun to pick up in the spleen. Her kidneys start to produce urine and her gallbladder secretes bile. By week 10 the heartbeat can be detected electronically. By week 12 hard bone centers appear in the skeleton, especially in the skull and long bones, and the genitals appear well differentiated.

With the organs and limbs of the fetus now sketched out, she will start to grow and function more fully. She will become increasingly responsive to stimulation and will develop an extensive repertoire of reflex movements. And as she starts to outgrow her home, the uterus will stretch and begin to expand the mother's belly so that by the end of pregnancy it will weigh over two pounds by itself and have a volume of more than a gallon—a staggering 500- to 1,000-fold increase in size.

URINE PRODUCTION

By week 20 the fetus produces up to three tablespoonsful of urine per day. She will continue to produce urine for the rest of her time in the womb, although it follows a tortuous route before she is completely rid of it. Filling and emptying her bladder every 20 to 30 minutes, she excretes urine into the amniotic fluid, and from here it is swallowed. This waste is then reabsorbed from the gut into the bloodstream and eventually makes its final exit across the placenta. From then on, her mother has to deal with it.

Body boom: 12-week fetus →

GESTATION: 09 weeks | LENGTH: 2.0 inches | WEIGHT: 0.3 ounce • GESTATION: 12 weeks | LENGTH: 3.4 inches | WEIGHT: 1.6 ounces

HAIR

Hairs begin to develop during weeks 9 to 12, but they do not become easily recognizable until about week 23. They are first seen on the eyebrows, upper lip, and chin. Each hair grows from a hair follicle in the deep layer of the skin. Hair patterning and growth are influenced by the development of the central nervous system: Infants with neurological abnormalities may have abnormal hair whorls or variations in the direction of hair growth and the amount of hair—differences possibly related to excessive tension on the skin during the formation of the follicles.

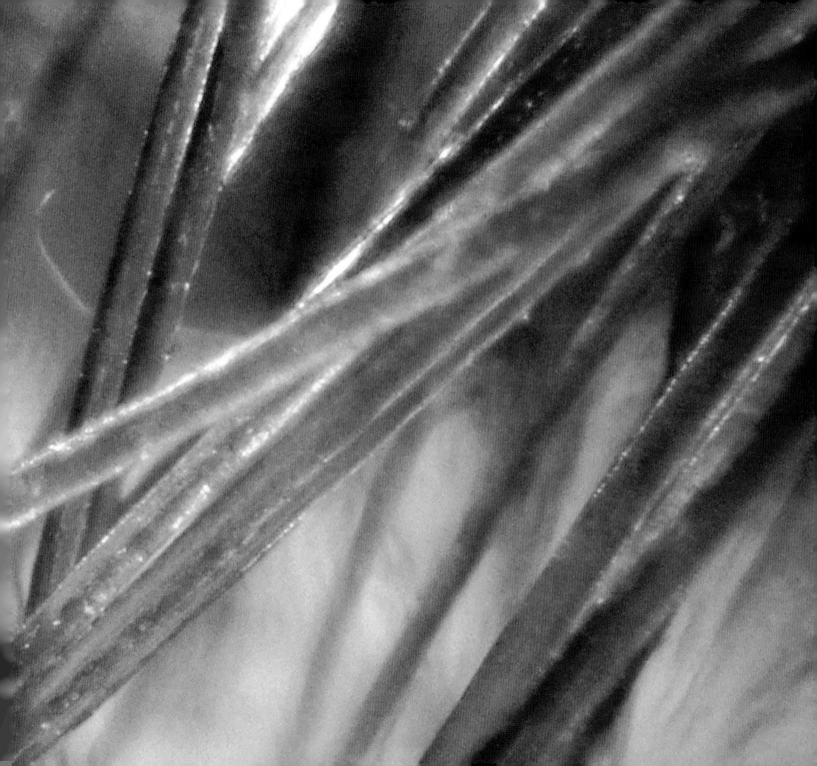

SEXUAL CROSSROADS

Initially as they develop, male and female fetuses have identical reproductive organs. They don't begin to look different until the seventh week.

Although both gonads begin to develop during the fifth week, the testes start to differentiate in the seventh week, whereas the ovaries are not identifiable until the tenth week. By the twelfth week they are very different and already hard at work: For a male, the testes are producing testosterone, and for a female, the ovaries are preparing to pack primitive egg cells into their follicles.

Researchers have identified a gene on the Y chromosome that is the master regulator of sex determination in males, acting as a switch that directs the transformation of the indeterminate gonads into testes. Testosterone produced by the testes then ensures that the reproductive tracts and genitals develop as male. Known as the sex-determining region on Y, or SRY, the gene activates a few other critical genes that are needed for masculinity or deactivate others needed for femininity. Or perhaps it does both—more than 15 years after its discovery, we still don't know how it works exactly.

What we do know is that male embryos appear more developed at five days than female embryos, so SRY could govern growth rate, enabling males to reach a critical turning point before females and take the exit for testis development. If the embryo doesn't get there within a certain window of time, then the exit is blocked and the indeterminate sex organs have no choice but to continue on the road to ovary development. In other words, the default sex is female—no SRY and the embryo will develop as a female.

VANISHING TRACTS

Male and female embryos initially have two adjacent pairs of reproductive tracts: the Wolffian and Müllerian ducts. Both sets are present during the fifth and sixth weeks, when the embryo could develop into either a male or a female. The male tract grows out of the Wolffian ducts, which are the urine-collecting ducts of the interim "ancestral" kidneys—an example of the ingenuity of evolution in co-opting similar structures to do different things in different species. Testosterone, produced by the testes, stimulates the Wolffian ducts to become the sperm ducts, and the indeterminate external genitals to become the penis and scrotum. Meanwhile, another substance produced by the testes—"Müllerian inhibiting substance," or MIS—makes the Müllerian ducts vanish.

By contrast, female sexual development does not depend on the presence of ovaries or hormones. The Wolffian ducts disappear because of the lack of testosterone, whereas the Müllerian ducts develop into the uterus and Fallopian tubes because there is no MIS to inhibit them.•

Girl or boy? Genitals appear at first as a protrusion with a central groove →

ALL IN THE ANGLE?

BODY ACTIVE

In the third month, the fetus bursts into action. Her nervous system is developing fast, generating an average of 2.5 million neurons every minute. Aided by support cells called glial cells, the neurons spread through her body and migrate along pathways into her brain, where they connect with each other and become active.

This is the beginning of a neural network that will operate as an integrated whole, though the integration process won't start until the sixth month and will continue for many years after birth. But by the time the baby is born, she will be receiving information from more than 10,000 taste buds in her mouth, 240,000 hearing units in her ears, and up to 50 billion light-sensitive points in the retina of her eyes.

Her whole body is now beginning to twitch spontaneously. The next four weeks will see her kick, turn her feet, and curl her toes. She will bend her arms at the wrist and elbow, form partial fists with her tiny hands, and reach up to cover her face with her hands. Her face, with its sealed-shut eyes, will squint, frown, purse its lips, and open its mouth. She will begin to respond to touch—as early as the eighth week touch pads appear around her mouth and she will bend her head away from a touch around her mouth. (Later, she will turn her mouth toward the touch, a reaction that in newborns is called the rooting reflex.)

These movements have a crucial role in stimulating the growth of muscles and strengthening joints, though the fetus is too small for the mother to feel them. At this stage the nerves may extend only from the muscles of the leg, for example, back to the spinal cord, with the connection to the brain still growing. So the brain is not yet controlling the fetus's movements. They are still involuntary reflex spasms.

The heart is not yet controlled by the brain either, but is marching to its own beat. And it has been gaining speed since it first twitched into life at the end of the third week. After starting at a feeble 20 to 25 beats per minute, it now pumps as fast as it will ever go—a frantic 157 beats every minute. An adult heart rate is normally 70 to 80 beats per minute. After this peak the heart will slow down as it, along with the rest of the body, gradually comes under the brain's control.

Until now, the fetus has been hidden from the outside world. But the mother is about to get her first glimpse of the secret events unfolding inside her womb.•

Supporting cast: Star-like glial cells or "astrocytes" proliferate in the brain →

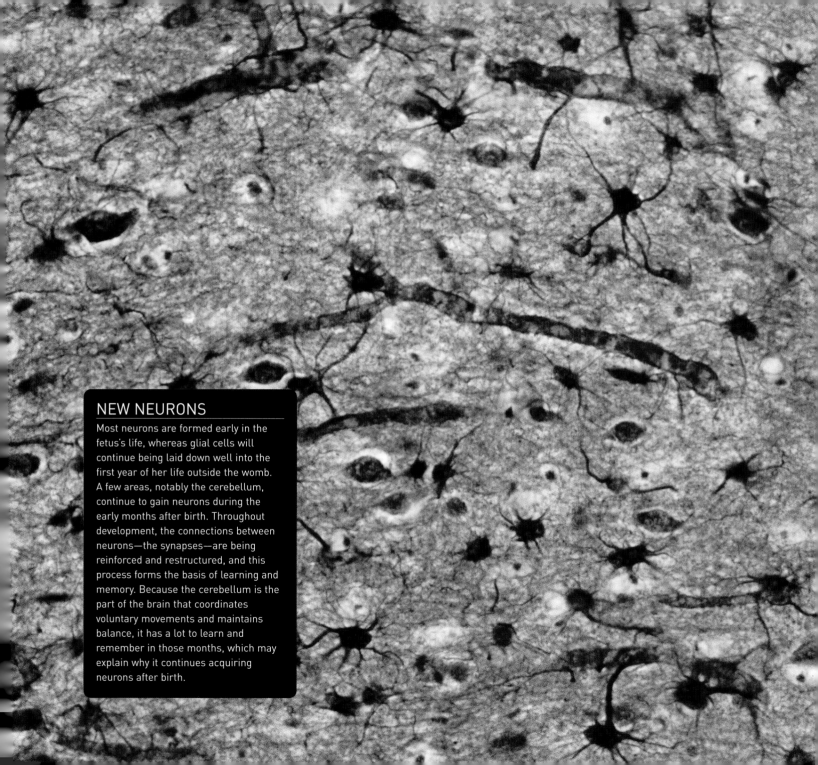

NEW NEURONS

Most neurons are formed early in the fetus's life, whereas glial cells will continue being laid down well into the first year of her life outside the womb. A few areas, notably the cerebellum, continue to gain neurons during the early months after birth. Throughout development, the connections between neurons—the synapses—are being reinforced and restructured, and this process forms the basis of learning and memory. Because the cerebellum is the part of the brain that coordinates voluntary movements and maintains balance, it has a lot to learn and remember in those months, which may explain why it continues acquiring neurons after birth.

INNER VISIONS

Between week 10 and week 14, a pregnant mother may go for an ultrasound scan. Using ultrasound to peer into the womb has revolutionized our understanding of fetal development and care for the mother.

The pictures are produced by sending ultra-high-frequency sound waves—far too high for us to hear—from a probe into the body of the mother. The waves penetrate tissue, passing easily through fluid-filled areas like amniotic fluid, but bounce off solids like bone. The reflected waves are collected to produce an image of the mother's insides similar to an x-ray but without the danger: Ultrasound scans are not known to cause any harm to the fetus.

Inside the womb the fetus lives in fluid. Even her lungs are filled with fluid, and the ultrasound produces a moving image, which to a trained eye reveals much about her health and development. The scan can detect early, diagnostic features of genetic abnormalities. For instance, by combining measurements of the fluid-filled region of the fetal neck called the nuchal fold and two marker substances in the mother's blood, obstetricians can improve the detection of Down syndrome. This doesn't conclusively say whether a fetus has Down syndrome or not, but it does provide a better estimate of the risk and help physicians and prospective parents decide whether to follow up with invasive diagnostic procedures.

As well as checking the health of the baby, the first scan can predict a more accurate date for the birth based on the fetus's size instead of guessing from the date of the mother's last menstrual period. The ultrasound scan also reveals for the first time if the mother is carrying one fetus or two—or more.

Until recently, noninvasive research into the development of the human fetus has been restricted to grainy two-dimensional ultrasound scans and fetal autopsies after miscarriage. But research has now been revolutionized with the development of 3D scans, and even more remarkably, 3D scans that move in real time—known as 4D scans. By recording up to 16 images a second, obstetricians can directly observe how the fetus behaves and reacts to stimulation and how its reflexes help it to prepare for birth and survival outside the womb.•

FIRST FRAME

This 3D image is one of the earliest ever taken of a baby in the womb. It shows an embryo just six weeks old. The embryo is on the left, and the yolk sac—still bigger than the embryo—is on the right.

Fetal scans of face, ribs, heart, and the body in cross section (clockwise from top left) →

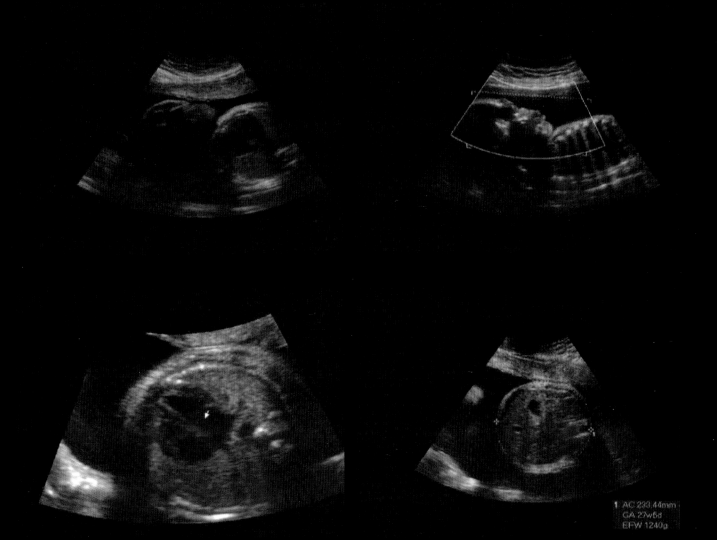

AMNIOTIC FLUID

Amniotic fluid plays a vital role in the fetus's growth and development. Made up mainly of fetal urine and tissue fluid from the placenta and the baby's lung, it is being reabsorbed and replaced continuously so that its entire water content is changed every three hours. Some passes through the membranes of the amniotic and chorionic sacs and into the uterine blood vessels; some seeps through the umbilical cord and into the fetal bloodstream; and some is swallowed by the fetus and absorbed by her developing lungs and gut. Of the fluid that passes into the fetal bloodstream, waste is filtered out by the placenta and taken up by the mother's blood, while excess water is excreted by the fetal kidneys and returned to the amniotic sac in urine.

As well as lubricating the fetus, amniotic fluid provides her with freedom of movement while protecting her from the outside world. It cushions her against external knocks and bumps, buffering her against pressure transmitted from one side of the womb to the other, and provides a sterile swimming pool maintained at a constant temperature (her temperature is almost a degree Farenheit higher than her mother's). As she floats in the weightless space of the amniotic sac, her face and body can shape up symmetrically, her lungs have room to develop, and she can exercise her muscles and nerves, pushing against the walls of the uterus and sac in practice sessions.

The volume of amniotic fluid at week 12 is about 0.9 fluid ounce (less than an eggcup full). It increases rapidly from mid-pregnancy onward, reaching a peak of 32 fluid ounces at about week 34, but then, inexplicably, plummets to as little as 10 fluid ounces by week 42.

AMNIOCENTESIS

Amniocentesis is a prenatal screening test where a sample of amniotic fluid is removed from the amniotic sac. The cells, proteins, minerals, and other chemicals in the fluid can tell a physician a lot about the fetus's health and maturity.

Toward the end of pregnancy, the specimen can be taken through the cervix. But amniocentesis can also be carried out early in pregnancy, at around week 15 or 16, when the specimen is taken through the abdominal wall using a long, fine needle. This may be necessary if the parents' family history suggests serious genetic or chromosomal conditions such as Down syndrome, which may be revealed by analysis of stray cells shed into the fluid—usually from the sac or from the fetus's skin, mouth, bladder, or windpipe. It can also be used to determine how mature the fetus's lungs are, whether the fetus is undernourished or has congenital abnormalities such as spina bifida, and the sex of the fetus (important where there is a family history of sex-linked genetic disease).

Because pregnant women over the age of 35 have an increased chance of carrying a baby with chromosomal abnormalities, they are commonly advised to consider having an amniocentesis. Preliminary tests on the mother's blood may strengthen the case. Amniocentesis carries a small risk of inducing miscarriage (less than 0.5 percent).•

BOUNCING IN THE WOMB

Even though the baby won't be able to walk until she is around a year old, the building blocks for her first steps are present after just 11 weeks in the womb. These sequences show 11- and 12-week fetuses rhythmically kicking and pushing out their legs in what is known as the stepping reflex.

A reflex action is a preprogrammed nervous impulse. When her feet touch the base of the uterus, the nervous system triggers an automatic reaction in the muscles of the legs.

At this age, there is so much space in the uterus that the fetus bounces and leaps around, using the walls of the womb like a trampoline. The ability to walk is an important survival skill, and the more the fetus moves, the stronger the reflex grows.

This stepping reflex can clearly be seen in newborns when they are held upright with their feet dangled on the ground: they will try to take a step. This reflex disappears shortly after birth.

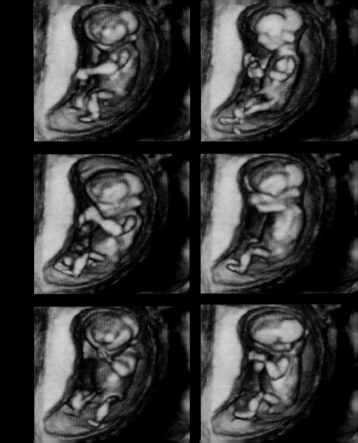

THE SECOND TRIMESTER

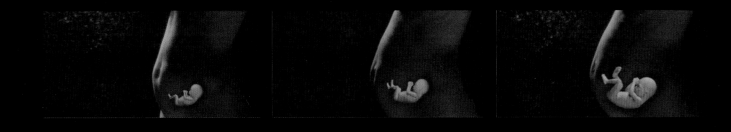

GROWTH AND COORDINATION WEEKS 13–16

During the second trimester—the middle three months of pregnancy—the fetus grows rapidly and develops complex coordinated activities. Whereas in the first trimester her focus was on cell differentiation and division, now she relies solely on cell division.

At 13 weeks she has well-developed organs. Although still no bigger than a fist, she is much less delicate and there is less risk of a miscarriage. Between 13 and 16 weeks her body will shoot up. No other single month of the pregnancy will witness comparable growth.

Most of the elongation takes place in the body. Her legs lengthen, and the top-heavy appearance given by her oversized head becomes far less noticeable. Her eyes grow closer together, giving her a more human look, and her ears stand out from her head. Her first thin, transparent layer of skin begins to replace the temporary protective membrane that shrouds her. Whorls of hair patterning are discernable on her scalp.

Her fingers and toes are separate and defined, and her toenails start to develop. Hands mature before the feet, which could be because hands are going to be used first once the baby is born, or it could be because the hands, being important sensory organs, develop at the same time as all the other senses. Her ovaries are differentiated and contain primitive follicles with precursor egg cells, and in both boys and girls the genitals are recognizable.

The fetus is still running on reflexes, but big changes are taking place. Her nervous system is up and running and her limb movements are increasingly controlled and coordinated by her brain. With muscles flexing, she is much more mobile now. She is making practice-breathing movements and can suck her thumb, swallow amniotic fluid, and pass urine.

Her bones continue to harden and can now be seen in ultrasound scans. The changing of cartilage to bone—or the direct formation of bone, as in the skull—places considerable demands on the mother's supply of calcium and phosphorus, as these elements are used to build up the rigid layers of the fetus's bones. The process, known as ossification, is now well under way and will not be complete until after puberty. Some small bones of the hands and feet, for instance, are still entirely cartilaginous at birth.

HEAD AND LEGS

At two months the fetus's head takes up half her total length; from three to five months it is 33 percent of the whole body; by birth it will be 25 percent; and in the adult roughly 10 percent. The opposite happens with the legs. At two months they account for only about 25 percent of the total length of the fetus; at five months they are 33 percent; at birth 40 percent; and in the adult about 50 percent.

Tough stuff: 16-week fetus with hardened bones (yellow) →

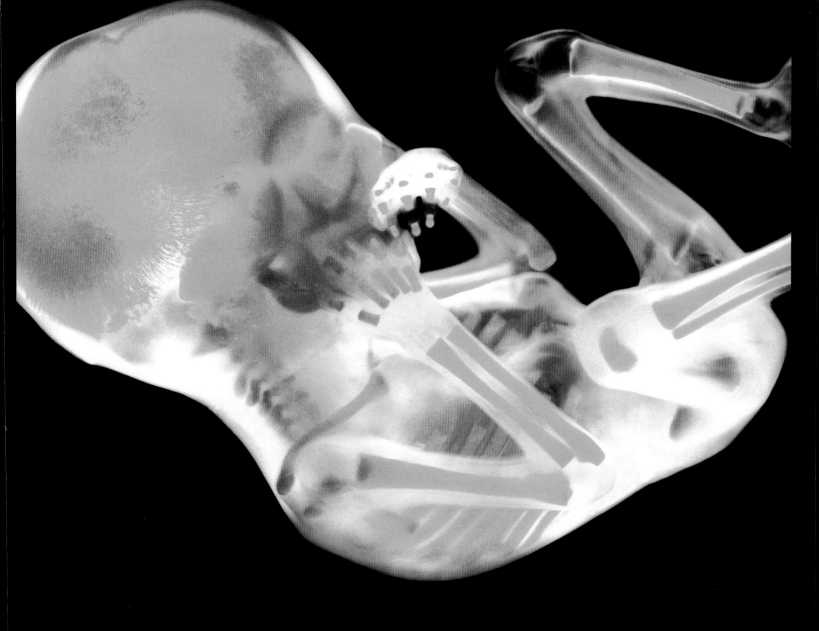

GESTATION: 14 weeks | LENGTH: 4.7 inches | WEIGHT: 3.9 ounces • GESTATION: 16 weeks | LENGTH: 5.5 inches | WEIGHT: 7.1 ounces

TAKING CONTROL

The central nervous system extends its connections from the brain to most parts of the body, allowing the brain gradually to establish total control.

The heart, for instance, is no longer beating spontaneously and sporadically. Instead, the brain regulates its muscles and keeps them pumping blood at a steady 140 to 150 beats per minute, roughly twice an adult's heart rate. Using an instrument called a Doppler probe, it is now possible to hear what a baby's heart sounds like.

As the nervous system extends throughout the fetus, so too does her capacity to respond to stimuli. She is becoming increasingly sensitive to touch, and if prodded through the abdomen, she is likely to squirm.

From four months on, the fetus makes a lot of intricate movements. She can bend, flex, and twist her extremities, her fingers, wrists, legs, and toes. Incredibly, she is already beginning to develop an awareness of the space around her.

This awareness is called proprioception—the unconscious sense of our body's place in space that helps us to interact with our environment and coordinate our movements. Sensors give constant feedback to our brain, allowing our movements to be refined and eventually perfected. This feedback starts early on in the womb: The mother's movement coupled with the buoyant amniotic fluid provides plenty of opportunity for stimulation of the fetus's "vestibular apparatus," the sensory mechanism in her inner ear that detects movement and helps to control balance.

SPEEDING UP TRANSMISSION

Much of the growth of the nervous system in the second trimester is due to the laying down of myelin, a fatty protein coating that insulates the nerves and allows signals to be transmitted more rapidly. In the brain and spinal cord, sensory nerves are insulated before motor nerves, which carry impulses instructing muscles to contract. But outside the brain and spinal cord, in the peripheral nervous system, motor nerves are insulated before sensory nerves.

Because insulation greatly increases the speed at which nerves can transmit impulses, the differences partly account for the limited integration of movement and the senses in the fetus. Insulation begins in the spinal cord as early as week 18, whereas in the brain it doesn't start until week 35, and much of it doesn't get completed until after birth. Areas responsible for "higher" functions such as cognition and learning aren't insulated until later in life.

The order of insulation parallels the overall development of the function of the nervous system, the brain last. In fact, its relative lack of myelin is one of the reasons why the brain can be seen in ultrasound scans throughout gestation.•

Fired up: Animated sequence of activated branches of neurons →

GAINING A HOLD

As the fetus explores her body, she spends lots of time practicing her grasping reflex, grabbing hold of her hands, feet, fingers, toes, and even her umbilical cord. Although the grasp develops as early as 16 weeks, full strength is not acheived until 32 weeks.

The clues to the origins of the grasping reflex may lie in our ancestry. Life is relatively simple for a newborn: She will be carried around in her mother's arms, in a sling, or in a carriage. For a newborn ape, survival depends on the ability to cling to the fur of her mother as she forages for food or escapes from predatory claws, and it seems likely that the grasping reflex is a legacy of our shared evolutionary descent.

Human babies are less dependent on this reflex for survival, but the fetus will still develop an incredibly strong grip. Newborn babies will use their fingers to grasp any objects placed in their hands. And if the soles of their feet are tickled, their toes flex in a grasping movement.

Identical twins first come into contact with each other at 12 weeks, and by 14 weeks are touching arms, legs, bodies, and mouths. These close contacts seem to occur earlier between female twins. Non-identical twins are separated by membranes in the womb and don't have the same opportunity to bond with their sibling.

As identical twins grow bigger they are almost always in contact, touching hands, faces, and feet, and gradually becoming more aware of themselves and each other. This constant contact in the womb is mirrored in early life, and is partly responsible for the incredibly close bonds that twins feel throughout their lives.•

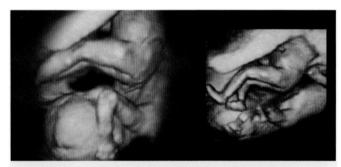

COMPETITION AND COMPANIONSHIP
The scan on the left shows the membranes separating a pair of non-identical twins just above the elbow of the lower twin, across the middle of the picture, whereas the scan on the right shows the intimate contact in the womb between identical twins, who in most cases are not separated by membranes.

Handgrip: A fetus grasps and plays with her umbilical cord →

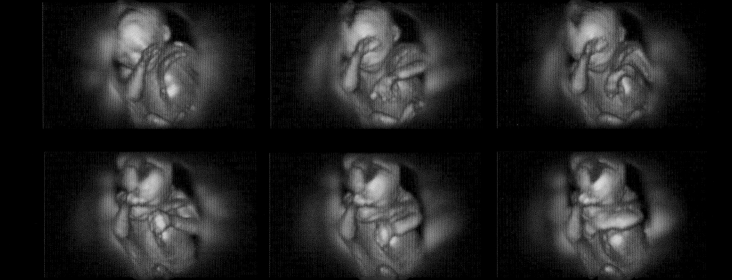

TWINS, TRIPLETS, OR MORE

Non-identical, or fraternal, twins develop when two eggs are fertilized at the same time. As a rule a woman's ovaries release only a single egg each month, but if two or more happen to be released together they can be fertilized by two separate sperm. In this case the twins don't share the same DNA, so they may be of the same sex or different sexes. In other words they are as physically and genetically dissimilar as any brothers or sisters born at different times. Non-identical twins are always separated in the womb, each living in its own amniotic sac, and also have separate placentas.

Identical twins are formed when a fertilized egg or early embryo splits in two. The twins will share identical DNA and so are of the same sex and are very similar in physical appearance. Depending on when the cleavage occurs, identical twins may share the same placenta. In only one percent of cases will they share the same amniotic sac.

About two-thirds of twins are non-identical. According to a handy rule of thumb, non-identical twins occur about once in every 85 births, triplets about once in every 90x90 births, quadruplets about once in every 90x90x90, and quintuplets about once in every 90x90x90x90. The formula is roughly correct, but there are marked racial differences in the likelihood of having non-identical twins, and the chances increase with maternal age. Interestingly, for both race and maternal age, it is the rate of non-identical twinning that varies around the world. The likelihood of identical twins is almost universally constant at about 1 in 300 births.

Unlike identical twins, the tendency to have non-identical twins runs in families, and this propensity seems to be inherited through the female line. Families with one set of non-identical twins are about three times as likely to have a subsequent twin pregnancy as are families from the general population. The main cause is an increased risk of multiple ovulation, in which a woman releases two or more eggs in a given menstrual cycle rather than the normal one egg. Mothers of non-identical twins not only have a much higher rate of multiple ovulation than normal women, but they also secrete follicle-stimulating hormone—the hormone that controls the release of eggs—in more frequent pulses. Researchers have not yet found the genetic factors responsible, although the prime suspects are mutations in genes that alter the response of the ovary to follicle-stimulating hormone.

So if you're a woman, the chances of having non-identical twins are increased if your mother, sister, or aunt (on either your mother's or father's side) has had non-identical twins. If you are a man and you want twins, you should look for a woman who fits this description, because your father does not appear to influence your chances, although he can pass the tendency to his daughters.

Another thing to consider is the mother's age: A woman who gives birth at 37 is four times as likely to have non-identical twins as she is at 18, although she is also more likely to be unable to conceive because many women's ovaries are already starting to fail at that age. And also bear in mind the question

of race: The incidence of non-identical twins ranges from 1 in 500 births in Asians, to 1 in 125 in Caucasians, to as high as 1 in 20 in some African populations.

All the above only applies to spontaneous births. The introduction of assisted reproduction techniques, particularly when hormones are used to stimulate ovulation, has seen a dramatic rise in multiple births. They also slightly increase the chance of having identical twins, which suggests that there may be some connection between the two types of twinning. What's more, the initial, "hidden" twinning rate is probably higher. With increasing use of ultrasound in early pregnancy and monitoring of transferred eggs in *in vitro* fertilization, doctors are discovering that before 12 weeks one of the twins may die and be absorbed, leaving a single baby—the so-called vanishing twin syndrome. It turns out that a staggering 12 percent of pregnancies may begin as twins, with up to 70 percent of these converted to singleton pregnancies when one dies.

Identical twinning usually begins at the blastocyst stage, around the end of the first week, and results from the division of the inner cell mass into two potential embryos. The outer trophoblast stays connected, so the two embryos, each in its own amniotic sac, develop in one chorionic sac and share a common placenta. Occasionally, early splitting of the ball of embryonic cells—during the two- to eight-cell stage—results in identical twins with two amniotic sacs, two chorions and two placentas. The placentas may or may not be fused, depending on how close to one another the twins implanted in the uterine wall. In such cases it is impossible to tell from the membranes alone whether the twins are identical or non-identical.

If cleavage is as late as 7 to 15 days, it is the embryonic disk that divides, resulting in identical twins sharing the same amniotic sac and chorionic sac. Accounting for only 1 to 2 percent of all identical twins, they are rarely delivered alive because their umbilical cords become so entangled that their blood supply gets cut off. Division after 13 days is often incomplete, in which case various types of conjoined twins may form, though some researchers believe they result from the fusion of two separate, early embryos rather than the incomplete fission of one. Just over 1 in 100,000 births are conjoined twins.

About 15 to 30 percent of identical twins who share the same chorionic sac develop a serious condition called twin-to-twin transfusion syndrome, or stuck twin syndrome. Here one fetus "steals" most of the blood from the placenta, and the other twin will not develop properly because it cannot obtain enough nutrients or get rid of waste. In the worst cases the condition can result in the loss of both babies, the "donor" dying from anemia, the "recipient" from congestive heart failure.

Multiple pregnancies are more prone to complications than single pregnancies, not least because of the hazards of premature birth and poor growth in the womb. So the mother's prenatal care needs to be more closely monitored.•

DETAILED LOOKS WEEKS 17–20

Four months have passed since conception, and the fetus is more than halfway through her journey toward birth. Over the next month her growth slows down.

Her arms and legs have reached their final relative proportions. Brown fat starts to be deposited in pockets at the nape of the neck, behind the breastbone, around the kidneys, and in the groin area. This specialized insulating tissue produces heat by burning fatty acids. Babies born prematurely or simply underweight have very little brown fat, which is why they have such difficulty maintaining their body temperature and become cold very quickly.

Her delicate skin is coated with a thick, whitish, greasy material called vernix caseosa, which consists of dead skin cells and a fatty secretion from her sebaceous glands. This cheesy covering protects her skin from fingernail scratches and from becoming chapped and waterlogged during the many weeks that it is immersed in the mineralized amniotic fluid. It also insulates the fetus and lubricates her so she is easier to deliver at birth. Her whole body is now completely covered with lanugo hair, which helps to keep her warm until she has sufficient fat stores and holds the vernix on the skin. She is showing an incredible level of anatomical detail. She has her own hair and even fingerprints and toeprints.

By 18 weeks, her uterus has formed and the vagina starts to take shape. In boys, the testes begin to descend. Lung development continues. As the airways branch out and the tiny terminal air sacs proliferate, a bed of fine blood vessels forms in preparation for the exchange of oxygen and carbon dioxide with the air.

The mother may have a more detailed second ultrasound scan around this time, which surveys the anatomy of the fetus and measures its rate of growth since the last scan. These scans are performed only for medical reasons, to help to predict possible complications and abnormalities. For example, 4D scans are especially helpful for diagnosing a cleft palate.

Doctors have discovered that for parents-to-be, the scans also help to develop an emotional connection. Researchers have shown that seeing the face and expression of the developing baby while it is still inside the womb can be an intense bonding experience. This can provide an important boost to the baby's development once it is born and also to the long-term relationship between the child and her parents.

QUICKENING

Around this time, when the fetus is about 18 weeks old, the mother may become aware of her growing fetus's movements for the first time. Although the fetus has been active for quite some time, it's only now that her movements are strong enough for her mother to feel. Women who have been pregnant before tend to be more alert to this slight fluttering sensation—or "quickening"—in their lower abdomen and may feel it when the fetus is just 15 weeks old.

In proportion: 20-week fetus →

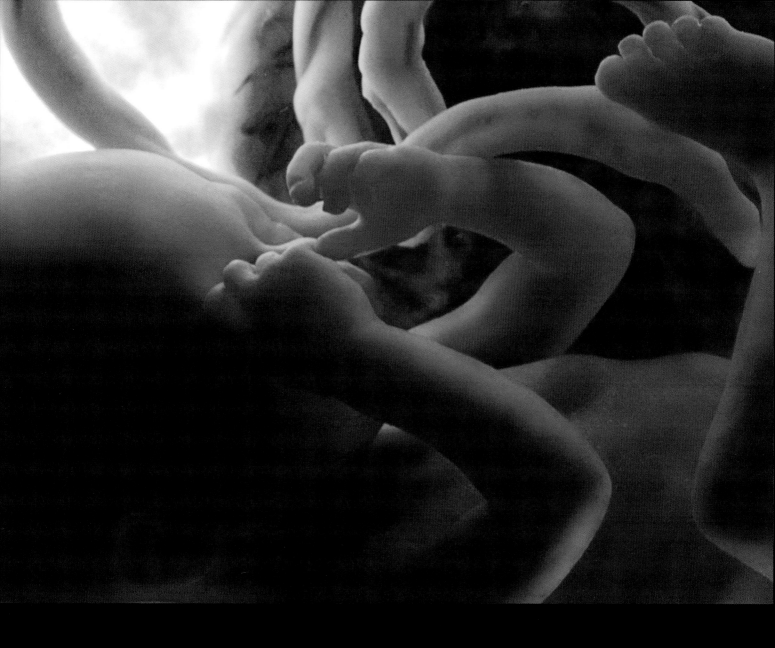

GESTATION: 18 weeks | LENGTH: 6.3 inches | WEIGHT: 11.3 ounces • GESTATION: 20 weeks | LENGTH: 7.5 inches | WEIGHT: 1 pound

FINGERPRINTS

As cells in the surface layer of the skin proliferate, they form ridges that extend into the deep layer of connective tissue and lay down the future fingerprints. Studded with sweat glands that open through pores on their crests, these ridges begin to appear at 10 weeks and are permanently established by 17 weeks, with those of the hands seen before those of the feet.

The moistening of the ridges, combined with the texture of the corrugations, increases friction and thus improves grip when they come into contact with objects. The pattern of ridges that develops is determined genetically and is unique to each individual, and so provides an infallible method of identification in criminal investigations—serendipitously, the sweat secreted onto the skin ridges leaves an oily image of the pattern on any surface touched.

Fingerprints are also of use in medical genetics, because chromosomal abnormalities can affect the development of ridge patterns. Infants with Down syndrome, for example, have distinctive ridge patterns on their hands and feet.

DIGESTIVE SYSTEM

After about 18 weeks, the fetus begins to anticipate life outside the womb. Her digestive system shows signs of activity. She has no need to eat or drink, but she is swallowing the fluid she floats in—the amniotic fluid. Amniotic fluid contains nutrients, hormones, and growth factors that help to regulate her gut and aid its growth and maturation.

Some indigestible waste—dead cells and debris from the fetal liver, pancreas, and gall bladder—gathers in her intestine in the form of a greenish black paste called meconium, which she normally passes as her first stool after birth. But most of the fluid passes through her urinary system and back out to rejoin the amniotic fluid.

Swallowing begins at 10 to 14 weeks, at the same time as the small intestines begin to produce the waves of involuntary contractions that push food and waste through the digestive system. The gut also develops the ability to absorb glucose. It is not clear what stimulates swallowing, but it could be thirst.

Fetal taste buds—which develop around the same time—may play a role because when saccharin is injected into the amniotic fluid this increases swallowing, whereas noxious chemicals inhibit it.

By 14 weeks the lining of the small intestine looks like velvet under the microscope. It is coated with millions of little protrusions or villi, which together present an enormous surface area for absorption of nutrients, minerals, and water.

The fetus's digestive system has no real work to do until after birth, though, when it must begin to deal with food—in particular, milk. At birth the stomach produces no acid, and in place of the protein-digesting enzyme pepsin the baby has rennin, which starts the digestion of milk protein without the help of acid.

But the fetus does produce insulin that promotes the uptake of glucose from the blood by the body's cells. Without it, she wouldn't be able to consume glucose as fuel or adequately store it.•

**Tasty beginnings: The fetus swallows
the fluid she floats in →**

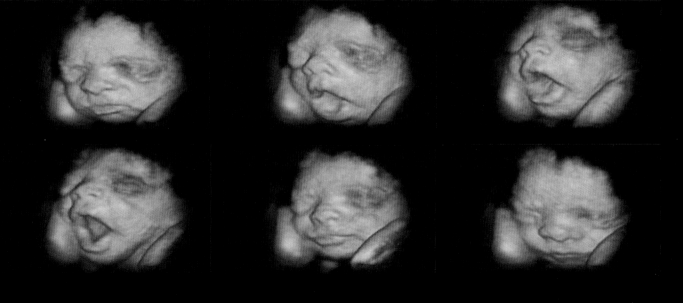

THE LUNGS

The lungs don't function during the fetus's time in the womb—all her oxygen is delivered from her mother's blood via the placenta. Inside the fetus's lungs, the branching network of tubes is filled with amniotic fluid during the entire time in the womb, and the tiny air sacs that extract oxygen from the air remain closed and immature.

But the fetus still makes breathing movements with her lungs and diaphragm. Respiratory muscles develop early, and movement of the chest wall can be detected by ultrasound as early as 11 weeks. This helps to strengthen the chest muscles so they are ready to expand and fill the lungs with air the moment the baby is born.

As birth approaches, the movements of breathing become more regular and pronounced, and continue to draw fluid into the lungs. By 24 weeks, fluid produced by the lungs themselves is mixed in. The lung fluid has an unexpected but vital function. If the inside of the lungs were moistened with pure water, the surface tension around the thousands of tiny air sacs would collapse the lungs and empty them of air as effectively—and by the same mechanism—as pricking a bubble.

After birth, however, the tiny air sacs need to be coated with an extremely thin layer of water to help them absorb oxygen. To prevent their collapse, the lung fluid contains a detergent-like substance—a "surfactant" secreted by special cells lining the air sacs—that lowers the surface tension to a point where the lungs can stay open and easily hold air.

Surfactant production in the lungs seems to be stimulated by cortisol, one of several hormones involved in triggering contraction of the uterus in labor. Secreted by the two adrenal glands, which sit on top of each of the kidneys, cortisol is perhaps best known as the "stress hormone," produced with epinephrine at times of crisis to prepare the body for "fight or flight."•

Breathing space: The lungs' air sacs, magnified 1,000 times in this scanning electron micrograph, continue to form for at least eight years after birth →

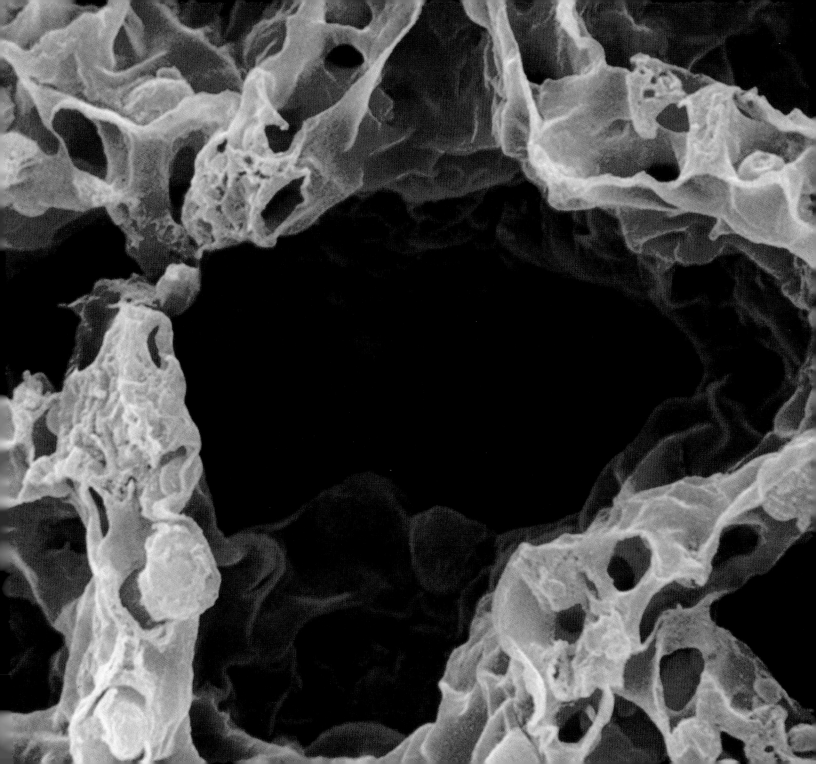

STILL SHUT

The fetus's eyes are generally thought to remain fused shut until 25 or 26 weeks, but 4D ultrasound has revealed fetuses opening their eyes as early as 18 weeks. There is nothing to see because of the darkened womb environment, which may become grayer as the uterus grows and stretches. But even if there were enough light, the eyes don't work this early. This opening is just the first sign of the blinking reflex.

Lifting the lids: The fetus will soon open her eyes →

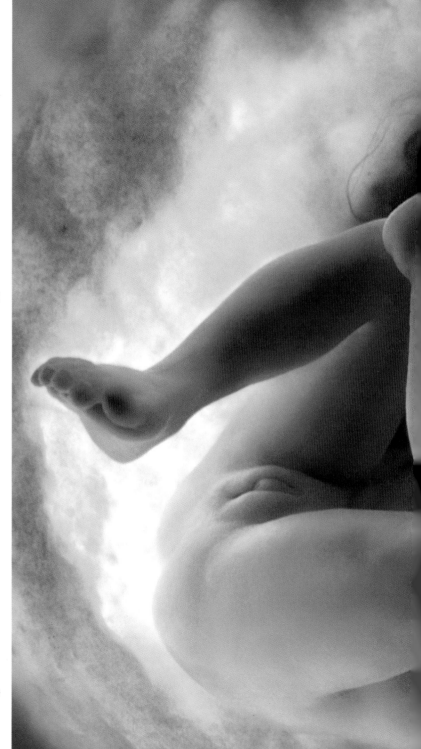

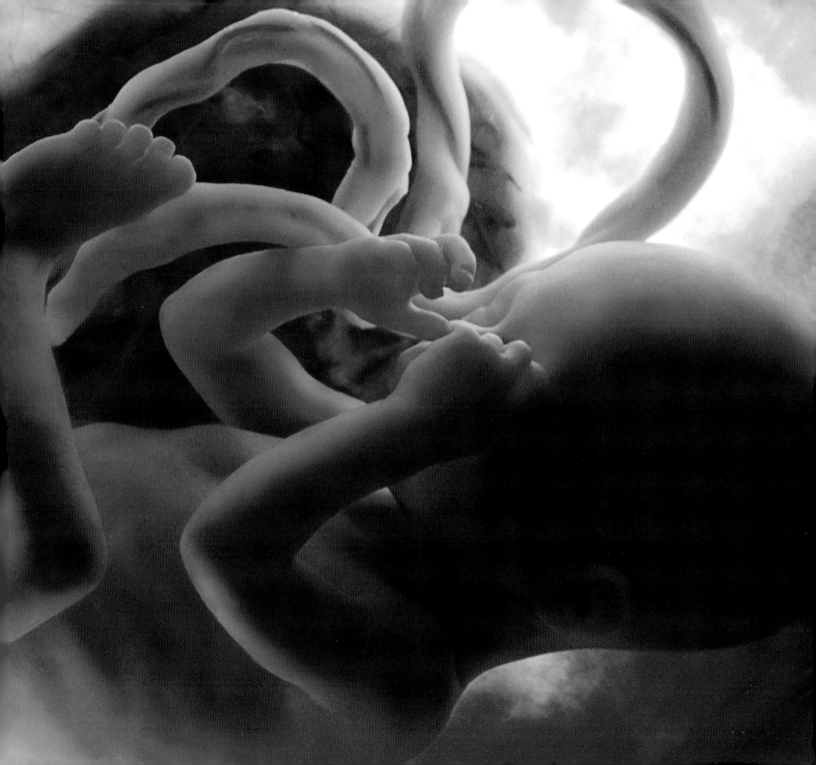

TRANSLUCENT SKIN WEEKS 21–25

The fetus puts on substantial weight between 21 and 25 weeks. Although still lean, she is better proportioned.

Red and wrinkled, she is covered with fine, translucent skin beneath which blood vessels and bone are visible because she still lacks subcutaneous fat. Her fingernails are all in place and her eyes are structurally complete. At 21 weeks rapid eye movements begin—an activity associated with dreaming in which the eyes flicker back and forth behind closed eyelids. When a loud vibrating noise source is applied to the mother's abdomen, the fetus responds by blinking and starting—a reaction that usually develops earlier in girls than boys. The fetus's vocal cords are functioning—she can get hiccups—and movements such as grasping and pedaling are coordinated.

By 25 weeks the bony skeleton is fully assembled although not yet connected at the joints. At birth the baby has a total of 300 bones, though some later fuse, which is why an adult has just 206. The 222 bones needed to support her in a vertical position continue to harden and knit together. At the moment they contain as little as 12 percent calcium compared with the 90 percent calcium of adult bones.

The human spine alone is made up of 33 rings, 150 joints, and 1,000 ligaments, all of which have begun to form. But there will be remarkable variation in the end result: About 95 percent of people have 30 vertebrae, 3 percent have one or two more, and 2 percent have one fewer.

After six months of pregnancy, at the end of the second trimester, everything has developed and is working almost as it will in the full-grown baby. It is all there—just very small and immature. With three months to go before birth, growth is the big job for this little girl. With all her organs in place, now they need time to develop and mature while she puts on some fat and learns how her body works.

Around this time, the mother becomes more and more aware of movements made by the fetus. Her abdomen continues to grow, and she is likely to be feeling better now than at any time throughout her pregnancy—very energetic and active. She is over the effects of morning sickness, and the fetus is not yet big enough to cause the kind of discomfort she will feel at the end of pregnancy.

Fattening up: 24-week fetus →

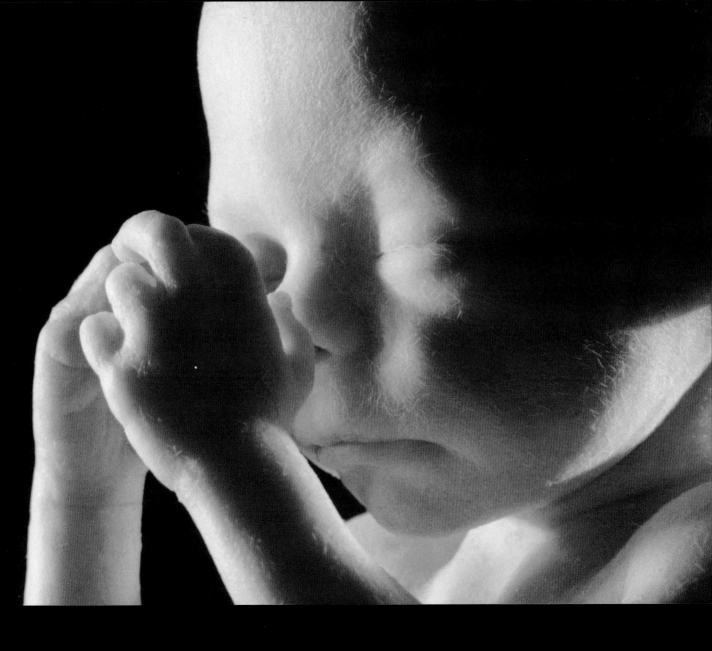

GESTATION: 22 weeks | LENGTH: 8.3 inches | WEIGHT: 1.4 pounds • GESTATION: 24 weeks | LENGTH: 9.1 inches | WEIGHT: 1.8 pounds

THE THIRD
TRIMESTER

EXPLORING THE WOMB WEEKS 26-28

Our baby is booming. As she progresses through the third trimester toward birth she will grow half as tall again and more than triple in weight.

In the next four weeks her brain and nervous system continue to grow dramatically. Her eyes open again as the lids unfuse and grow intricate eyelashes. Head hair and lanugo are well developed, toenails are visible, and subcutaneous fat has arrived, smoothing out many of her wrinkles. Her spleen is an important site of blood formation, but by 28 weeks the bone marrow has taken over.

By week 26, the baby's parents may get a pleasant surprise: It is now possible to hear her heartbeat just by putting an ear to the mother's abdomen. The baby's heart beats about twice as fast as her mother's. Monitoring it gives a good indication of her general condition.

The mother's heart rate and blood pressure are directly affected by her emotional state. If the mother is calm, her heart slows down and her blood pressure drops. If she is tense and stressed, her heart beats faster and her blood pressure rises. Although the baby has her own blood supply, these increases in heart rate and blood pressure are easily passed through the placenta and have a direct impact on the baby. It takes a while for the effects to filter through, but as the mother recovers from stress and her heart rate returns to normal, her baby's heart begins to race as the physiological signals of stress creep through the placenta.

In the short term, stress in the mother can lead to low birthweight or premature birth. But it is also possible that a mother's prolonged anxiety and stress can be passed on, establishing a tendency for stress in her child and making her more likely to develop chronic health problems such as heart disease and diabetes. It can even have a harmful effect on the child's mental development in the early years of her life.

HEART SOUNDS

The heartbeat of the fetus can be distinguished from that of the mother by taking the mother's pulse while listening to the fetal heart through a stethoscope. It can be heard with a stethoscope by 20 weeks. When listening for fetal heart sounds the obstetrician may also hear a "funic souffle," the sound of blood rushing through the umbilical blood vessels, and a "uterine souffle," the sound of blood passing through the dilated vessels of the placenta. The swishing of the first sound is in step with the fetal heartbeat, whereas the murmuring of the second sound is associated with the maternal pulse.

Smooth and hairy: 26-week fetus →

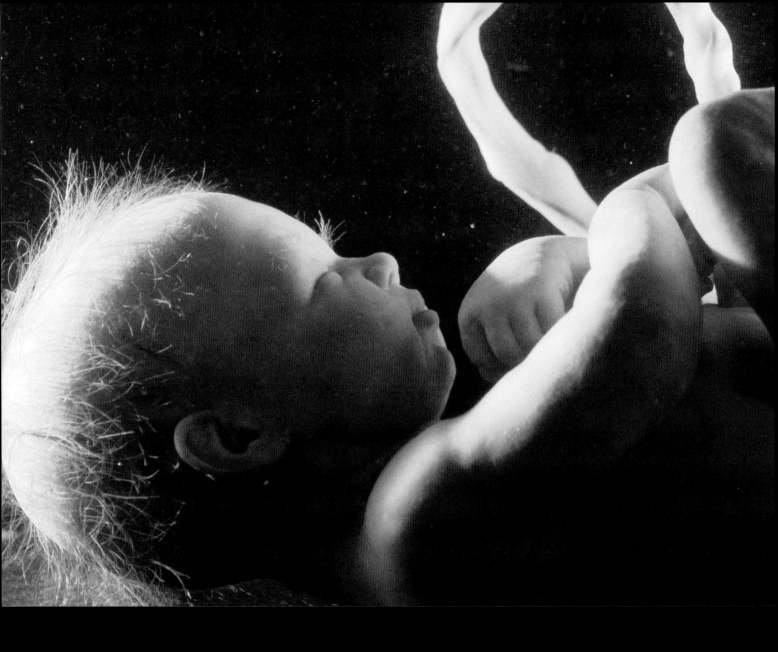

GESTATION: 26 weeks | LENGTH: 9.8 inches | WEIGHT: 2.2 pounds • GESTATION: 28 weeks | LENGTH: 10.6 inches | WEIGHT: 2.9 pounds

SURVIVING ON HER OWN

Between 26 and 29 weeks the fetus reaches a major landmark. Although barely longer than her father's hand, she could survive outside the cradle of the womb. She'd still need intensive care, but her central nervous system is mature enough to direct rhythmic breathing movements, coordinate contractions in her digestive tract, and control her body temperature, and her lungs and their blood vessels have developed sufficiently to exchange oxygen and carbon dioxide with the air.

In rare cases, babies survive when born as young as 22 weeks, especially if they do not have too low a birthweight. But any baby born prematurely faces an increased risk of brain damage, with nearly half of all babies born before 26 weeks developing disabilities or learning difficulties.

A normal baby at term weighs about seven-and-a-half pounds. Babies weighing less than one pound at birth usually do not survive. Most of those weighing between three and five-and-a-half pounds survive but complications may occur.

In North America, even if the pregnancy has not been complicated, around 60 percent of twins, 90 percent of triplets, and almost all quadruplets and higher-order multiple births will be born prematurely, before 35 weeks. In addition, 55 percent of twins and 94 percent of triplets will be of low birthweight, compared with only 6 percent of singletons. Regardless of their birthweight, these babies will behave less maturely than singletons and will require help with breathing and feeding during the first few days or weeks of their lives because they have not fully developed the ability to suck or swallow. Other complications associated with premature babies include an immature nervous system, kidneys, and other organs. In addition, they are usually vulnerable to infection and cold.

Ultimately, what matters is the stage of the baby's development at birth. This is why infants born at full term, at 38 weeks, yet small enough to suggest prematurity (described as "small-for-dates") need special attention too.•

HIGHER FUNCTIONS

Until now, the cerebral cortex of the brain has been relatively unwrinkled, but grooves and furrows have begun appearing on the outside surface, and along with them come greater, more localized functions. Made up of four lobes, the cortex is involved in many complex brain functions including memory, attention, perceptual awareness, thinking, language, and consciousness, but the connections that underlie these functions have largely yet to develop.

Crossing the threshhold: The baby can now thrive outside the womb →

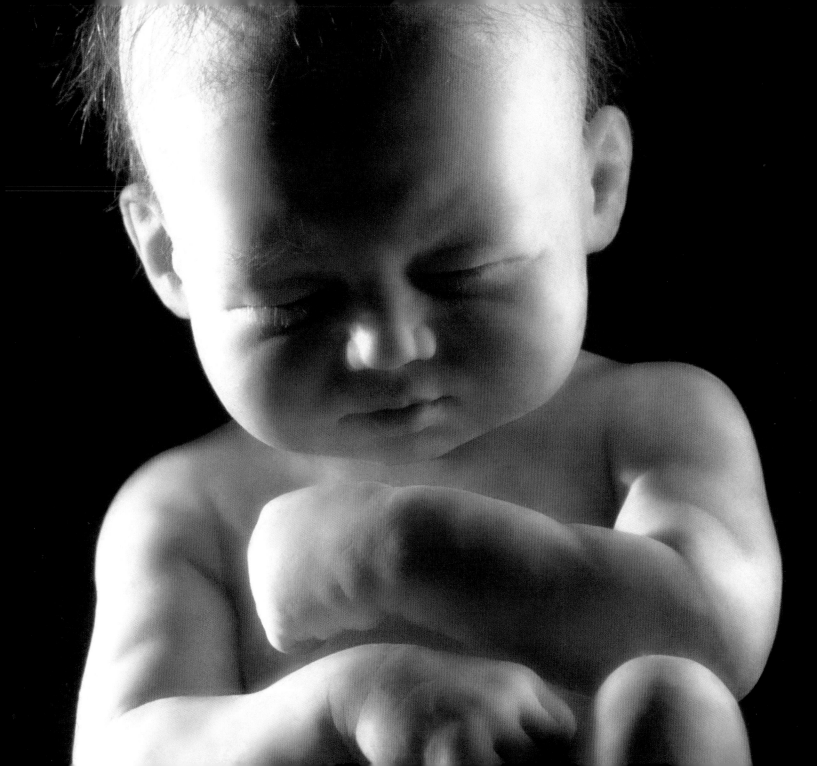

OPERATION

Most fetuses that reach 26 weeks will make it through to birth with no problem. They simply put on weight and exercise their reflexes and senses. But sometimes things do go wrong.

Take, for example, the case of a 26-week fetus who develops a hole in his diaphragm—the muscular membrane that separates the lungs from the abdomen. Caused by incomplete fusion of the membrane, the defect is not a problem at that stage, but his intestines will grow into the lung cavity, which will stop the lungs from developing properly. When he is born, he will almost certainly be unable to breathe and will die.

Professor Kypros Nicolaides, a world-renowned pioneer of fetal surgery at King's College Hospital in London, has developed a technique that blocks the windpipe of the fetus with an inflatable bladder, which raises fluid pressure in the lungs, forcing the intestines back where they belong and allowing the lungs to develop properly. This surgical procedure relies on a fetoscope to visualize the fetus inside the womb. A fetoscope is a long, narrow tube filled with fiber-optic filaments. Light travels down one set of fibers to illuminate the inside of the uterus, and reflected light is sent back to a camera so the surgeon can see what he is doing. The fetoscope also carries the delicate instruments needed to conduct the operation.

The first step is to inject an anesthetic into the fetus to keep it from moving. The mother is awake during the entire procedure, with only a local anesthetic to numb her. A general anesthetic would be too harmful for the baby. Professor Nicolaides then inserts the fetoscope through an incision in the mother's abdomen into the amniotic cavity.

He gently pushes the fetoscope into the fetus's mouth and down the back of the throat. Inside the windpipe, he inflates a tiny balloon that traps fluid inside the lungs. As the fetus grows the lungs produce more fluid, which raises the pressure and stimulates the lung tissue to grow and expand, forcing the intestines out of the chest cavity. The balloon is left in place for two months to give the lungs time to mature, then the fetoscope is inserted again and the balloon is removed in time for what everyone hopes will be a normal birth.

Since this operation has been available to treat babies with this defect, it has increased their chance of survival by 50 percent.

FETAL SURGERY

A more invasive type of fetal surgery involves operating on a baby while it is still in the womb. An incision is made through the mother's abdomen to allow direct access for the surgeon's hands. Once the surgery is complete, the womb is sutured and the mother delivers the child weeks or months later. Though still considered experimental, several hundred such operations have been performed in the United States and Europe.

Since the 1980s the technique has been used with mixed success to treat several conditions including urinary-tract obstruction, hernia of the diaphragm, twin-to-twin transfusion

syndrome, and a type of tumor at the base of the spine called a sacrococcygeal teratoma. Most recently, surgeons have operated on fetuses with spina bifida. By protecting at an early stage of development the nerves that would otherwise be exposed by the condition, they claim to have rescued limb movements and avoided the mental impairment usually associated with severe forms of the disease.

But there are risks: This type of fetal surgery appears to increase the chance of premature birth, and mothers may develop complications such as rupturing of the uterus and bowel obstruction. So like Professor Nicolaides, surgeons are increasing their efforts to develop minimally invasive, "keyhole" techniques using long, thin instruments that can be inserted through small portals in the mother's abdomen and guided by the latest diagnostic scanners.

There are many conditions that are currently being treated with such "intrauterine fetoscope surgery" in the United States and elsewhere, and this technique does seem to reduce the risk of complications.•

Through a keyhole: The inside of the windpipe as seen through a fetoscope →

AWAKENING THE SENSES

In the third trimester the baby embarks on one of the most exciting and dramatic periods of her development. This is the time when she receives her first stimulation from the world beyond as her senses flicker into life. Most of the sense organs—ears, nose, taste buds, and the nerves that respond to touch—are all now mature.

Her brain is being bombarded with signals from these sensory cells and she must begin to interpret this overload of sensation. Throughout her life her senses will be her window on the world: They will allow her to develop a sense of self, interact with others, explore, and learn. The new generation of 4D ultrasound scans continues to provide fresh insights into the behavior of the growing fetus and hence the response to sensory stimulation. Technology is advancing, and as the experience of practitioners evolves, new light is being shed on this once invisible world. In general, the senses develop in the following order: touch, proprioception (position and movement), vestibular (balance), smell and taste, hearing, and vision.

Scans reveal that at six months the fetus is often seen opening and closing her eyes. The eyes are fully formed halfway through pregnancy, but seeing is the one sense the baby can't experience until she is born. It's too dark in the womb. Very bright light—direct sunlight, for example—may penetrate into the uterus and the fetus may be able to detect a faint glow. But the uterine wall is so thick, buried under a protective layer of skin and fat, that most of the time the fetus develops in total darkness.

While there may be nothing to see, opening and closing the eyes helps the fetus to develop the blinking reflex that will stay with her for life, protecting her eyes from foreign objects, keeping them moist, and shielding them from bright light.

By week 28 the eye is sensitive to light, but perception of form and color and the ability to focus are not complete until long after birth.

Researchers have reported that fetuses can be startled by photographic flashes shined on the mother's belly and warn that exposing fetuses—and premature babies—to bright light can be dangerous. Damage to the retinas of premature infants, which has long been ascribed to the high concentrations of oxygen administered in intensive care, may actually be caused by overexposure to light too early in development.

The neurons forming the visual context of the brain are in place at 26 weeks, but the myriad connections between them have yet to develop. Signals from the retina of a baby at term are transmitted to the visual cortex and from there to the frontal lobes, where information is integrated. But a six-month fetus has a brain neither prepared for nor expecting signals from the eyes. Perhaps when the fetus is forced to see too much too soon, the premature stimulation may lead to defective brain development.

Iris: The ring of muscles that is developing to control the baby's focus →

The eyes already have eyebrows and eyelashes. But there is one detail that may not fully develop however much time the baby spends inside the womb—the color of the eyes. Some pigments in the pupils need light to form properly, and the baby's eyes may change during the first months of life. Babies of Asian and African descent are usually born with dark brown or dark gray eyes that mature to deep brown or black. A Caucasian baby almost always has blue eyes in the womb, even if they change to green or brown after birth. Geneticists used to believe that a single gene determines eye color, but new research shows that several genes are responsible. So it is impossible to predict just from looking at the parents' eyes what color their baby's eyes will be.

Scans show that at six months the baby also frequently sticks out its tongue. No one knows exactly why it does this, but it is known that her mouth is full of taste buds, so she could be tasting the amniotic fluid. As seen here under a microscope, the surface of the tongue has a surprisingly intricate architecture, full of hills and clefts containing the taste buds.

A baby's mouth and nose are permanently filled with amniotic fluid, which can carry the tastes and smells of the mother's food. This is because strong flavors pass easily from the mother's bloodstream through the placenta and into the baby's bloodstream, and are eventually passed into the amniotic fluid to give the baby an early taste of her mother's cooking.

A developed sense of taste and smell could help the baby to take her first sips of breast milk once she's born. Just like the amniotic fluid, breast milk contains a similar selection of tastes and smells from the mother's food. So if the baby is already familiar with these flavors, and likes the taste, this may encourage her to feed and influence her dietary preferences later in life.

There are three groups of smell receptors that bind to fragrance molecules, and they first appear between weeks 5 and 11. Taste buds develop in weeks 12 and 13. It is not known to what extent the baby experiences tastes or smells, but a 33-week premature baby will suck harder on a sweetened rubber nipple than on a plain rubber one, and a 26-week premature baby can respond to odor.

The baby may be completely surrounded by amniotic fluid, but because sound travels through fluid about four times as fast as it does in air, she has plenty to hear. And there is little question that a baby can hear, as any pregnant woman who has felt a kick in the ribs after a door slams will attest.

The first sounds the baby hears, though, as her ears start picking up vibrations at 24 to 25 weeks, are the gurgles and rumbles made by her mother's body. A succession of hiccups, burps, bubbles, sloshes, and slurps marks the passage of food, liquid, and air through the maze of passages and tubes just inches from the baby's ears.

Taste buds: A microscopic view of the surface of the tongue →

The fetus also makes her own noises as she kicks and swishes in the amniotic fluid. And she can hear the competing thuds of heartbeats, her own racing at twice the speed of her mother's. Both are her constant companions during her time in the womb. She can also hear sounds from the world outside—conversations, loud noises, and music. All sounds reach the fetus distorted, but higher sounds are more muffled because the abdomen and walls of the womb filter out most of the high frequencies. So only the lower, bass notes of music have much affect. Voices will sound distorted too. Vowels are generally lower in pitch than consonants, so the fetus hears only the melody of speech, without the percussion of consonants.

The mother's voice will sound different from any other since it travels directly through the fluids of the body. This may help the baby to develop the unique relationship it has with its mother. Researchers have found that the fetal heart rate slows when the mother is speaking, suggesting that the baby not only hears and recognizes her voice but also is calmed by it. Other voices, like the father's, must pass through air and then fluid, and may not cut through the general background noise.

The loudest sound a baby will ever hear may come during an ultrasound scan. It's impossible to hear the actual ultrasound waves—their frequency is far too high to be detected by the human ear. But the ultrasound can cause secondary waves in the amniotic fluid that the baby can hear. To produce finely detailed images ultrasound probes fire a rapid succession of pulses, each lasting less than one millionth of a second.

The rapid switching on and off of these pulses can cause waves in the fluid, which sound like a high-pitched tapping. If the probe is pointed directly at the baby's ear, it can sound as loud as a subway train. In normal circumstances there is no need for the scanning probe to go anywhere near the ear, but if the baby becomes at all unhappy, she can easily wriggle away from the sound.

The structures of the auditory system, including the inner ear and the cochlea (the spiral tube that converts sound vibrations into nerve impulses), are mature enough to support hearing by 20 weeks. Very premature babies entering the world at 24 or 25 weeks respond to sounds around them, but these have to be louder for them to hear than if the baby had been born at term—in other words, babies get better at hearing as they get older.•

Ossicles: The three little bones in the middle ear that transmit sound vibrations are now cartilaginous →

PAIN AND PLEASURE

Four-dimensional ultrasound scans reveal fetuses grimacing and frowning as doctors manipulate them through the mother's abdomen. This is all part of the delicate extension of the senses, for along with the development of the senses may come the development of pain. Pain receptors appear at about 7 weeks, initially around the fetus's mouth, and by 20 weeks they can be found throughout her body. Pain pathways in the spinal cord are insulated with myelin at 22 weeks, and it seems that the fetus can respond to painful stimuli before regions of her brain that normally process pain are developed.

But is the fetus experiencing pain at this stage? Researchers have commonly described such responses to stimulation before 26 weeks as reflexes, not dependent on conscious appreciation. But they are more equivocal about fetuses after 26 weeks. This is because at 26 to 34 weeks the nerve fibers from the thalamus—the region of the brain involved in the processing of pain—penetrate the developing cerebral cortex, the area that plays an important part in consciousness.

Yet although the structures are in place and the brain is advanced, researchers still can't be sure that the fetus can actually feel pain. What most agree on is that pain is a multidimensional experience that involves the senses, emotions, and thinking—and the jury is still out on just how developed these faculties are in the fetus.

But even a lack of response to pain does not imply its absence.

Until recently, newborn babies were assumed to be relatively insensitive to it. And because anesthetists worried about the risks of anesthesia in newborn babies, major operations were often carried out on babies who were effectively paralyzed, not anesthetized. But the levels of stress hormones in these babies were found to be alarmingly high, and this has led to a change in attitude to neonatal surgery.

If newborn babies do feel pain, then at what stage can a fetus first feel pain? This is an urgent question now that surgeons can carry out operations on fetuses before they are born. Anesthesia is today routinely administered to fetuses as young as 20 weeks who undergo prenatal surgery. As well as possibly reducing pain, this also helps to immobilize them and make the surgery more effective (although there is evidence that fetal anesthetics are more risky for the mother).

Whatever the fetus is feeling, at 20 weeks she is certainly capable of demonstrating lots of facial expressions. 4D scans have revealed babies not only grimacing but also seeming to smile and even laugh.•

Signs of emotion? Babies making a range of facial expressions. →

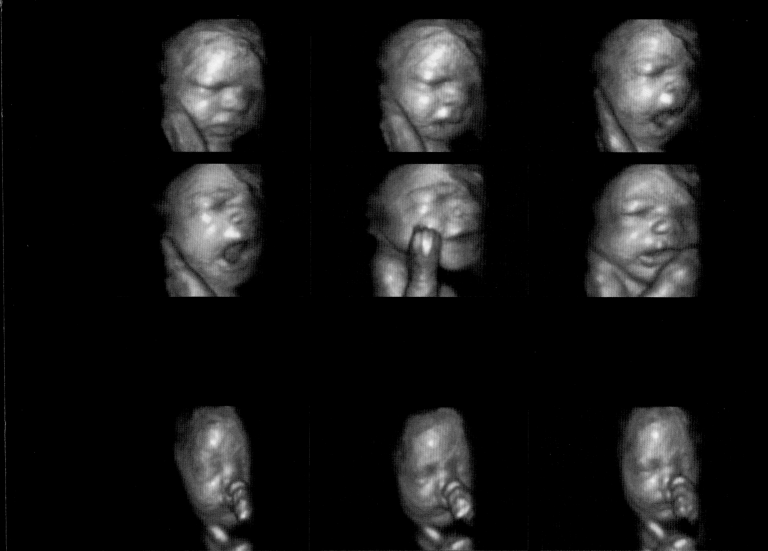

TRICKS AND SKILLS

During the final trimester, the baby prepares for life outside the womb, away from her comforting cocoon with its built-in life-support system. Many of the crucial tricks and skills that she needs to survive on the outside are innate behaviors such as the sucking reflex that she develops in the womb.

SUCKING

One of the most important reflexes to perfect before birth is sucking. Anything vaguely nipple sized that comes close to her mouth triggers her attempts at the sucking reflex—a reflex that appears as early as 11 weeks. But the ability to suck from the breast does not fully develop until 35 or 36 weeks, whereas the rooting reflex, which assists newborns in locating and latching on to the nipple, is present at about 32 weeks. Ultrasound scans have shown that as soon as thumb-sucking begins, a baby tends to show a clear preference for either the left or right thumb. This left- or right-handedness, which stays with the baby for life, develops in the womb rather than in early childhood, as previously thought.

SWALLOWING

From the moment she is born and the cord is cut, the baby needs to have also perfected the art of getting food from her mouth to her stomach. Although she has been practicing swallowing since her third month in the womb, during the final trimester she will swallow about a pint of amniotic fluid a day—about the same amount of fluid as she will drink as a newborn. Drinking helps her digestive system to develop, and helps to maintain the salt and liquid balance in the sac.

STARTING

The startle reflex is thought to have originated from a time when infants were more at risk of being eaten by predators. A sudden noise or touch makes the fetus's arms and legs fling out to the side, the hands open, and the fingers spread. In newborn babies this may be an attempt at self-preservation, preparing them for whatever might happen next. It may not be so relevant to our lives today, but other reflexes are crucial to survival after birth.

HICCUPPING

By the third trimester, the mother can feel her baby move every day. Usually it is the baby kicking or pushing. But sometimes she may feel the regular twitch of her baby's hiccups, which are an involuntary, sudden contraction of the diaphragm. Why babies hiccup is a bit of a mystery. One theory is that it is a reflex that helps a baby to latch onto a nipple to feed. The spasm of a fetus's hiccup is strong enough to feel, but unlike our own hiccups, it makes no sound at all. The sound of an adult hiccup is made by the sudden rush of air that is stopped by the closure of the vocal cords. But in the baby's lungs there is no air, and hence no hiccup sound.•

Right-hander: A 25-week baby sucks its thumb →

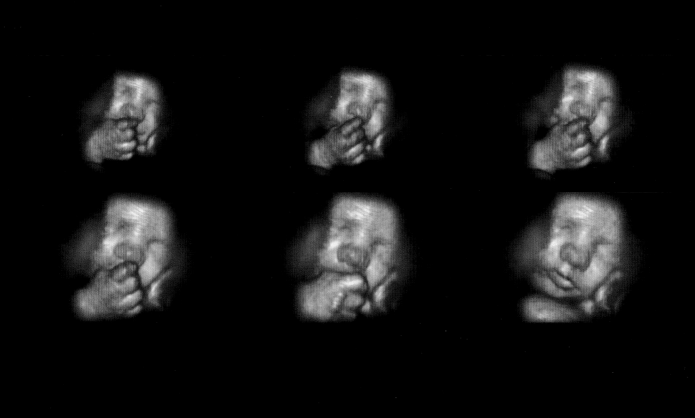

LEARNING AND MEMORY WEEKS 29–34

The baby is gaining weight fast as she lays down layers of fat and muscle under her thickening skin. Her body is filling out, and her arms and legs look chubby. Almost all lanugo hairs have been shed. Her skin is pink, smooth, and covered with vernix. Her fingernails extend to the fingertips.

Her senses are buzzing and her cerebral cortex has matured enough to support consciousness. Over the next four weeks, her nervous system will become as advanced as a newborn baby's. She is becoming aware of the world around her, and for the first time her brain is beginning to create memory. The fetus has spent so much time listening to her mother's voice that she has become familiar with its rhythms—she remembers them. With this constant exposure, she absorbs enough of these patterns to recognize and even respond to it. Researchers analyzing the cries of newborns found that the cries already contained some of the rhythms and patterns of their mothers' speech.

The type of music a baby is exposed to can alter her mood. Fast music stimulates and excites her. Music closest to the natural sounds and rhythms of the human voice—such as classical or choral music—has a sedating, calming effect. If she hears the same music over and over again, she may even remember it. At 33 weeks, just over 8 months, the baby may recognize a piece of music and even jump in time to it.

In one study, babies who had been exposed to a particular television soap-opera theme during pregnancy became alert and relaxed and stopped crying when the same theme music was played to them after birth. Babies who had not been exposed to the music in the womb showed no reaction at all. The researchers who conducted the experiment claim this is evidence of long-term memory at work before the baby is even born. In a similar study, mothers repeated a children's rhyme each day from week 33 to week 37. After birth, hearing the rhyme consistently led to a decrease in the babies' heart rate, suggesting that they had become familiar with this particular rhyme as opposed to similar ones they had not heard.

Some scientists argue that there is very little difference between the brain of a newborn baby and that of a 32-week-old baby. Where once it seemed that the mental development of a baby began at birth, now it appears that birth could be a relatively insignificant event in terms of brain development. She may have to feed and breathe for herself after birth, but as for thinking, learning, and remembering, she has already been hard at it for three months, and her brain will continue to grow at the same rate for the next year.

Intelligent looks: 32-week baby →

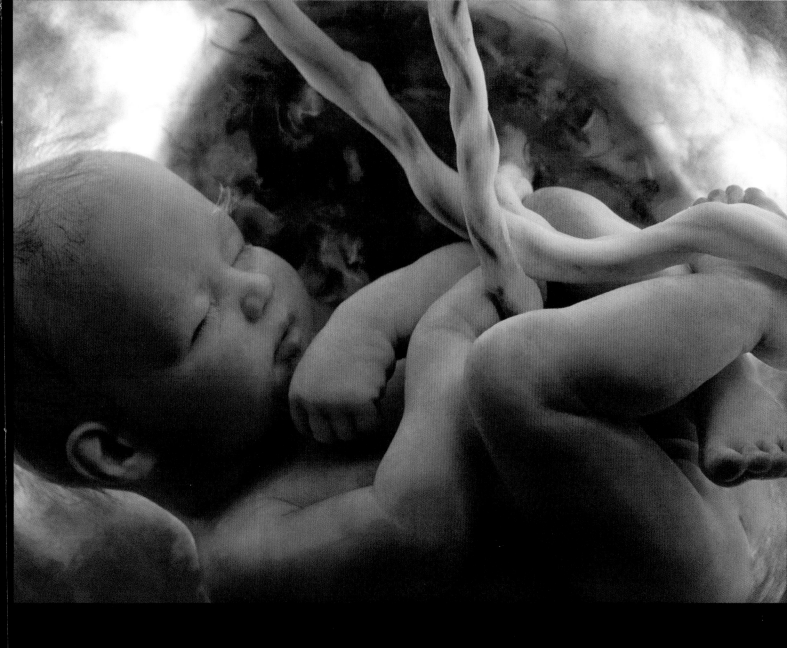

GESTATION: 30 weeks | LENGTH: 11.0 inches | WEIGHT: 3.7 pounds • GESTATION: 32 weeks | LENGTH: 11.8 inches | WEIGHT: 4.6 pounds

LIFE STORY

The time we spend in the womb can influence whether we suffer years later from obesity or heart disease, and it may even affect our ability to do mathematics. This is a new take on biological determinism: While the genes we inherit provide us with the basic blueprint for life and death, many adult diseases seem to be the result of the interaction between particular genes and the uterine environment.

While most research has looked at environmental influences after birth, studies are increasingly revealing that the nine months from conception to birth is the time when much of what will happen during the decades ahead is predetermined. Some of the root causes of heart disease, obesity, high blood pressure, osteoporosis, and type 2 diabetes have been traced back to conditions in the womb. Cognitive ability, longevity, and even earning power may also have their origins in the womb.

That elements of the uterine environment can affect the health of the fetus is not a surprise in itself. What is remarkable about the latest findings is that that pattern of disease might be programmed into the developing fetus as an unfortunate byproduct of natural selection.

According to the "fetal origins of adult disease" hypothesis, disease may originate from fetal adaptations to undernutrition, overnutrition, or unbalanced nutrition, or to other environmental factors such as changes in hormone levels, exposure to infections, and the general weight, fitness, and lifestyle of the mother. Evolution has equipped the fetus to predict its future environment from conditions in the womb and reset its growth plans accordingly. In other words, it makes a genetically determined developmental decision.

Faced with a shortage of nutrients in the womb, for example, she will allocate resources to give her the best chance to reproduce in early life at the expense of later years when she is likely to be either well past her reproductive prime or already dead. If the fetus anticipates her future environment correctly, then the developmental path chosen will lead to health in adult life and children of her own. But if the fetal prediction is wrong, then as an adult she will not have the settings appropriate to her environment and her risk of disease will be increased. In particular, fetuses adapted for a low-calorie, low-fat uterine environment that find themselves, through improved circumstances, in a high-calorie, high-fat postnatal world, can be expected to have health problems later in life.

It has long been known that babies who are particularly small grow into adults with a high risk of heart disease. Low birthweight has since been associated with a collection of symptoms known as "syndrome X." The symptoms are high blood pressure, disturbed fat metabolism, and obesity. These, in turn, indicate that a person is likely to develop heart disease and type 2 diabetes.

Perhaps surprisingly, the fetus seems to protect brain development even when resources are scarce. Babies conceived during a Dutch famine in the 1940s had abnormally

large heads compared with their body weights, as well as being more prone to heart disease and obesity in adult life. The high blood pressure associated with syndrome X stems partly from the way the kidneys develop. The kidneys of growth-restricted fetuses have fewer urine-forming elements or nephrons than those of normal fetuses. This saves resources, but means that each nephron has to work harder, which in turn means that they degenerate faster. The result is fewer and fewer nephrons working increasingly hard. Nephrons prevent dangerously high blood pressure by increasing urine production, so having too few of them results in hypertension. But it does not happen immediately. A study of conscripts in Sweden showed that low birthweight will have had no effect on blood pressure by the age of 20. But after the age of 50, the effect appears and then grows ever larger.

Exactly which genes are switched on or off in growth restriction is unclear. But the result is twofold. First, the fetus's tissues become more resistant to insulin—the hormone that enables glucose to enter cells so that it can be burned to release energy or used to make other molecules. Second, the fetus becomes more efficient at laying down fat deposits in later life.

Insulin resistance diverts glucose to the brain by keeping it available in the bloodstream. It stops muscles and other organs taking up glucose, but the brain, uniquely, does not need insulin to help it absorb this sugar. This allows the brain to develop normally even when the mother is having trouble getting enough food. Once programmed in, though, insulin resistance cannot be programmed out again. Insulin resistance causes blood-sugar levels to rise dangerously after meals, resulting in type 2 diabetes later in life.

Giving the developing fetus and growing child the ability to lay down fat in rare times of plenty is more obvious. But in today's world of constant plenty, both mechanisms are wreaking havoc. Even in the West, people conceived a decade or two ago are eating far more sugar and fat than their mothers did. The shift is greater still in many poor and middle-income countries. The result is epidemics of obesity, diabetes (due to too much blood sugar), and heart disease (due to high blood pressure and disturbed fat metabolism associated with changes in the body's fat-storing cells).

The "fetal origins of adult disease" hypothesis ties together many seemingly unrelated phenomena. A recent study of 1,487 elderly Germans found that people born in June, whose first trimester would have been in the winter, were 23 percent less likely to reach the age of 105 than those born in December. Perhaps they had been preparing for starvation because of worse seasonal nutrition during a critical period of development. Shortage of food in the womb may also explain why the rich live longer than the poor. Loss of bone density later in life is greater in people who did not grow well in the womb. And babies that have a short body relative to their head size but are within the normal weight range have problems with cholesterol metabolism, which may be caused by the

compromised growth of the liver as the fetus diverts oxygen-rich blood away from the trunk to sustain the brain. Protection of the brain certainly appears to give babies a "head start" in life. A study of a group of Finnish men born in 1940 showed that their size as one-year-olds was a good predictor of their incomes 50 years later. Those who were 28 inches long at that age had an average income of $27,000. Those who were 31 inches long had an income of $39,000. The assumption—supported by the men's school records when they were boys—is that this disparity is caused by differences in cognitive ability, which were, in turn, the result of variations in early growth.

Another study that started almost two decades ago looked at the effects of feeding 1,000 premature babies with a nutritionally enhanced "baby formula." Their development—effectively development that should have taken place in the womb—was compared with that of similar babies fed standard formula. The experiment lasted for a month from immediately after birth, before all the children were put on the formula. They were tested at the age of seven and again in their mid-teens. The boys who had had only standard-formula milk had notably lower IQs than the others. They were particularly bad at mathematics. At the time of the second test, researchers put several of them in a brain scanner and found that a small area of their left parietal lobes—an area known to be involved in mathematical calculations—was less active than expected.

These and other findings suggest that a change in diet might have an impact on health decades later. At first sight, the results look encouraging. Giving expectant mothers in poor countries a balanced dietary supplement of protein, carbohydrate, and fat boosts the birthweights of their babies. Similar increases are found when pregnant women are encouraged to eat green vegetables to obtain micronutrients such as vitamins and minerals. Policies based on "obvious" remedies don't always work as expected, however. For example, diets supplemented only by proteins actually stunt fetal growth, and pure micro-nutrient supplements have no effect on birthweight.

Research into the fetal origins of adult disease is opening up the possibility of being able to identify people at risk of disease and manipulating the uterine environment to improve health years later. But it poses a dilemma. Our understanding of fetal nutrition and development is far from complete. Is it better to act now on the basis of common sense or to wait a decade or more for scientific proof of how the future of our health is written in the womb?•

Under pressure: A tiny filtration unit in the kidney →

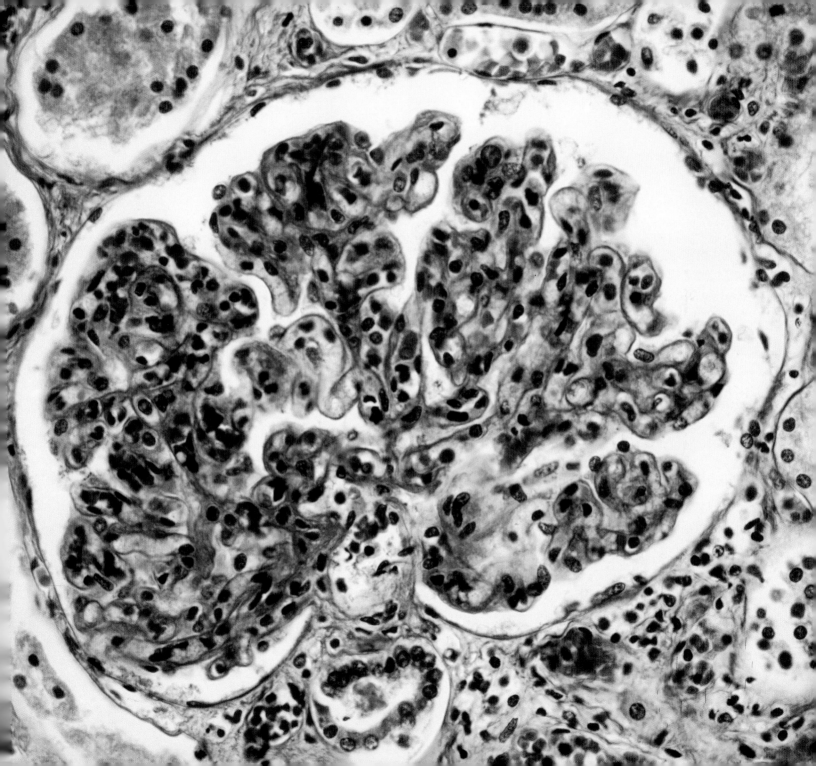

SLEEP

Four-dimensional scans reveal that babies experience rapid-eye-movement, or REM, sleep. This is a period of sleep when the eyes flicker around behind the eyelids. Later in life this is an indication of dreaming. This flickering could be a sign that the baby—still with more than a month to go before being born—is dreaming. Because she has little life experience, though, it is hard to imagine what she is dreaming about. But if anything it is likely to be about the sensations she feels in the womb as, for example, she plays with her feet or listens to the gurgling of her mother's stomach. But why dream? In adulthood, dreaming plays a part in consolidating memories, allowing us to make sense of events around us and develop strategies to deal with the world. In a baby, dreaming—however simple the dreams—may be the crucial process that maintains or establishes brain connections in the growing brain. REM occupies as much as 80 percent of sleep in the baby compared with 20 percent in adults, and it is known that sleep deprivation in a baby—or a newborn—can seriously impair brain development.

In early pregnancy, quiet and active periods alternate erratically. After five months, a cycle of what looks like sleeping and waking has developed—a cycle that isn't always synchronized with the mother's daily pattern. At around eight months the baby's eye and body movements, heart rate, and brain activity show signs of coordination, fitting into a regular cycle of REM sleep and deep sleep. During REM sleep, her heart rate is irregular and she twitches a lot, whereas during deep sleep her heart rate is regular and she hardly moves.

At 32 weeks, the baby drowses for as much as 95 percent of the day, even though she is continually stirring, moving some 50 times or more each hour. Some of these drowsing hours are spent in deep sleep, some in REM sleep, and some in an indeterminate state, a product of her immature brain that is different from sleep in a baby, child, or adult.

Closer to birth, our baby will sleep 85 to 90 percent of the time—the same as a newborn. Rest and activity become more clearly defined, and she seems to be not only awake but also alert between her frequent naps.●

Still life: Sleep develops as the baby's central nervous system matures →

GOING IT ALONE WEEKS 35–38

In just over nine months our baby's brain has grown around 100 billion neurons, with 100 trillion connections. Although it was the first organ to form, it is the last to be completed. Unlike most organs, which are virtually complete by day 50, the brain becomes more and more complex throughout pregnancy—and will keep on developing long after birth.

So although her head is relatively much smaller than it was earlier in the pregnancy, it still makes up a quarter of her length and has the same circumference as her abdomen. It has grown as big as it can in the womb and still be small enough to squeeze through the mother's pelvis. The rest of her body won't catch up and reach adult proportions until adolescence.

The baby can survive without much medical help if born anytime from about 35 weeks, although the longer she stays inside, the healthier she will be at birth. While her growth slows down as birth approaches, she adds about half an ounce of fat a day during these last weeks in the womb and looks plump. At birth, fat will make up 16 percent of her body weight.

Her fingernails extend beyond the fingertips. She has a firm grasp and can spontaneously orient herself to light. The vernix on her skin has become dislodged so that only her back is coated now, and she has accumulated a lot of meconium in her intestines. The amniotic fluid surrounding her is muddied with the vernix that has fallen off, and the spongy placenta has begun to degenerate to a tough, fibrous mass.

The final phase of pregnancy is a demanding one for the mother. Many women feel uncomfortable during the last couple of months. The weight of the baby, together with pressure on the spine and a battle for space, can make her back and legs ache. She may be feeling anxious about the birth and is likely to be short of breath as her lungs struggle to absorb 20 percent more oxygen than normal. Having begun as a single cell, the baby is now heavy and her quarters cramped. She is also a considerable nutritional drain on her mother, and the fat she is putting on is using up more resources than the mother can provide.

The baby can now hear, taste, smell, and feel. She is likely to be turned head down in the womb—getting ready for birth. For the mother, this change could be marked by some painful kicks in the ribs.

It is time to emerge.

Waiting game: 38-week baby →

COUNTDOWN

This is the final act in the drama, although it is impossible to tell exactly when the baby will be born. Only 5 percent of babies are born on their due date. The rest can emerge any time within two weeks of their expected arrival. The mother is kept guessing and waiting for signs: the "show" of a plug of mucus and blood from the vagina, the first contraction of the uterus, or the breaking of her waters as the sac ruptures.

Nobody knows exactly what initiates labor, but it is the placenta that determines the timing. It produced the hormone human chorionic gonadotrophin that started pregnancy. Now it produces a different hormone—corticotrophin-releasing hormone (CRH)—that ends it. This sets in train the release of other hormones, most notably from the adrenal glands, that lead inexorably to the expulsion of the fully formed baby from its uterine haven.

From the very first day of pregnancy, most of the subtle as well as the more dramatic changes in the mother's body are under the control of key hormones. These are produced from existing sources and glands in the mother's body, but increasingly, as pregnancy progresses, by the placenta and the developing baby. During the first few weeks, the placenta produces human chorionic gonadotrophin, which maintains the secretion of the pregnancy hormones estrogen and progesterone by the corpus luteum in the ovary. Levels of the hormone peak at 10 to 12 weeks and then decline rapidly as the placenta takes over control of the production of estrogen and progesterone. Estrogen boosts blood flow to the mother's organs, promotes the growth of the uterus and breasts, and softens connective tissue to allow ligaments to become more flexible. Progesterone, among other things, has a relaxing effect on blood vessels, tendons, and muscles, allowing the mother to cope with the increase in blood flow, accommodate the growing uterus, prepare the birth canal for delivery, and prevent contractions until birth.

The placenta makes CRH from very early in pregnancy, but output increases steadily until it eventually triggers birth. It now seems that this creeping increase in CRH is the timekeeper of human pregnancy. As CRH rises, it raises the levels of several other hormones that boost the production of estrogen. This estrogen boost in turn stimulates the uterus to contract, while also triggering the release of oxytocin and prostaglandin—two chemicals that drive the muscular contractions as well as softening the cervix so that it can open and let the baby through.•

Labor imminent: A baby approaches term →

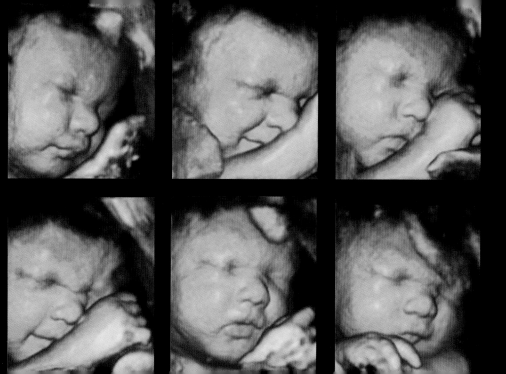

CONTRACTION HORMONES

Some women experience a minor "tightening" of the uterus, called Braxton Hicks contractions, for many weeks before birth, and for them the onset of labor can be indistinct. The contractions can be uncomfortable but are usually painless.

As well as "hardening" the uterus, they direct more blood to the placenta in the last weeks of pregnancy. They are irregular—rarely more than two an hour—and fade away, whereas labor pains start slowly and build up gradually in strength and frequency.

By the time of birth, the uterus has become the largest muscle in the woman's body, and it is prostaglandin that stirs it into action. The hormone occurs naturally in the uterine lining and stimulates the uterus to start contracting. The name "prostaglandin" was coined after it was found that semen contracted the smooth muscle of the uterus. It was thought that the substance responsible came from the prostate gland, but it is now known that prostaglandins are a group of biologically active compounds with a plethora of different actions and produced in virtually all tissues of the body.

Oxytocin—the other hormone that promotes contraction of the uterus as the baby enters the birth canal—is secreted by the pituitary gland. A synthetic version, syntocinon, can be used to start contraction of the uterus if labor is delayed. It is given via an intravenous drip inserted into a vein in the mother's lower arm. As well as stimulating uterine muscle to contract, oxytocin helps the uterus to shrink after childbirth and triggers the ejection of milk during breast-feeding. Stimulated by pressure on the vagina, by the baby sucking on the nipple, and even by the mother's seeing and hearing the baby, it exemplifies the interplay of hormones and nerves. Unlike most hormones, it is made in nerve rather than glandular cells, but stimulation of sensory nerves causes its release into the blood so that—like other hormones—it reaches its target site via the circulation. This nervous control means its actions are particularly fast.

Oxytocin also inhibits memory and may have a role in helping women to forget the pain of birth and bond with their new babies. One study of nursing mothers showed oxytocin makes women less reactive to stress hormones and so less anxious, bored, and suspicious and more calm and sociable. Intriguingly, a recent study suggests that the hormone also plays a part in the suppression of fear. Men exposed to oxytocin before viewing photos of threatening or frightened faces show two-thirds less activity in the amygdala—the brain region that registers fear—than do those not exposed to oxytocin. Although it has yet to be seen what effect the hormone has on the female amygdala, it is tempting to speculate that it may help women to overcome a natural fear of childbirth.•

Crystals of control: Oxytocin seen under a light microscope →

HEAD FIRST

Near the end of pregnancy the baby's head usually sinks down into the pelvic brim—a process called "lightening." In first pregnancies lightening can start as early as 36 weeks, whereas in the second or third pregnancies the head may not engage in the pelvis until immediately before labor starts.

The commonest position for babies to enter the birth canal (the cervix and vagina) is head down, with their tummy facing the mother's spine and their arms and legs drawn up in the classic fetal position. Most babies do not directly face their mother's spine, but are slightly tilted to the left or right. (For some reason more babies face the mother's right side than the left.)

This upside-down position is the most comfortable position for the baby as well as the easiest and safest for delivery. She moves into this position herself, the weight of her head helping her to nestle in. About 96 percent of babies born at term are in this position, whereas about 3 percent are "breech" or rump-down births.

By full term, the head is still the largest part of the baby's body, so its safe delivery through the birth canal during labor is imperative. This is one of the reasons why its skull bones do not fuse together until much later in the newborn baby's life. Although the baby's brain needs to be protected, its skull bones are quite soft compared with an adult skull and can slide over each other and overlap. This allows the head to mold to the shape of the mother's pelvis and greatly eases its passage through the birth canal.

During the first stage of labor, the baby's head is locked in the bottom of the uterus and is bearing down on the cervix—the muscular ring that acts as a barrier between the uterus and the vagina. The last thing to pass through the cervix was a tiny sperm 38 weeks ago. Now the cervix must stretch four inches wide to allow the baby's head to pass through.

Here's how it happens. The muscle fibers leading down to the cervix contract and relax at intervals of a few minutes, while those of the cervix itself relax. This opening up of the cervix is governed by changes in circulating hormones. As the baby's head pushes against it, nerve impulses from the cervix course back to the mother's brain, where they stimulate the secretion of more oxytocin. This then increases prostaglandin acting on the uterus, promoting further contraction. The more pushing, the more oxytocin, and the more oxytocin, the more pushing—and so the baby is steadily propelled downward.

The first stage of labor averages 12 hours for first pregnancies and 7 hours for women who have had a previous baby. For the mother, the pain of the uterine contractions can be eased if she delivers standing up, sitting, or squatting rather than lying on her back. This can also speed up the first stage of labor and reduce the likelihood of the mother needing medical interventions such as the use of forceps or a Caesarean.

As for the baby, each contraction slightly reduces her oxygen supply, because it also compresses blood flow to the vessels in the uterus that are supplying the placenta. This slows the

baby's heart noticeably—the "dips" on fetal heart traces. The squashing of the umbilical cord can also constrict the supply of oxygen. To help the baby cope, her body releases large quantities of epinephrine to keep the heart pumping fast enough. Epinephrine also helps to prepare her lungs for the lifetime of work they are about to begin.

Once the cervix is fully opened, the second stage of labor—the delivery—begins. It takes about 50 minutes for first pregnancies and 20 minutes for women who have had a previous baby. As the baby's head reaches the funnel-shaped muscles of the mother's pelvic floor, the mother feels an urge to push. Encouraged by the midwife, she augments contractions of the uterus with strong contractions of her abdominal muscles, which are more under her control than the uterine contractions. The contractions are now only minutes apart. After each contraction, the muscle fibers of the uterus remain a little bit shorter and push the baby farther through the cervix and the vagina, until her head is just visible.

Because of the bend forward from uterus to vagina, the baby's head must now be turned to allow it to be squeezed out. This is one of the most important—and painful—moments in the birth process, and it is usually the time when the midwife tells the mother to stop pushing.•

**The final push: Smooth-muscle cells
in the outer wall of the uterus →**

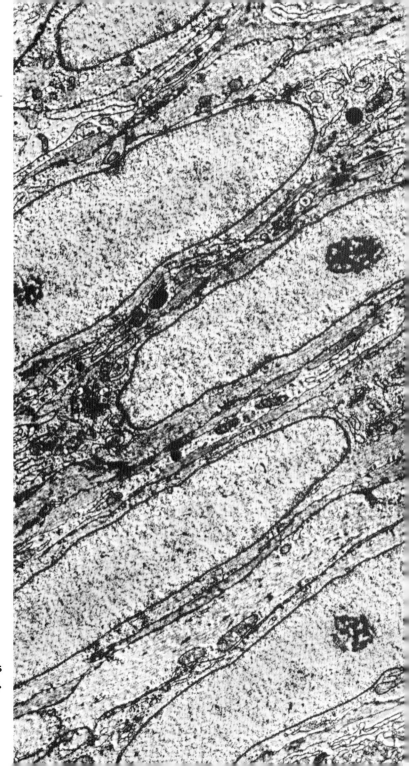

SYSTEMS CHANGEOVER

The baby suddenly finds herself in a completely strange environment to which her organs must adapt. Some organs, such as the liver, kidneys, and endocrine glands, need little adaptation. They have gradually begun to work in the womb in conjunction with the mother's glands. But two functions have to be established at once if the baby is to survive: the provision of oxygen and of warmth.

As soon as the baby has been delivered, her lungs drain of fluid and air rushes in, expanding the air sacs that in an instant begin extracting oxygen to keep the baby alive. Two things probably trigger her all-important first breath: her chest as it recoils after being squashed in the birth canal and, more important, her gasps, provoked by the dip in oxygen supply during her birth and by the sudden shock of cold air afterward.

The first gasp does more than just help to overcome the surface tension in the lungs and allow her to breathe. It also leads to a wholesale shift in the plumbing of her circulatory system. While in the womb, her circulation is designed to receive oxygen and nutrients from the placenta and distribute them around her body. Her heart acts just as a single pump, maintaining blood flow throughout her body and into the placenta.

Suddenly, her circulation must now grab oxygen from the air and nutrients from her intestines. In other words, her heart must act like a double pump, maintaining blood flow throughout her body while getting blood to and from the lungs.

In adults, blood is pumped around the body by the left side of the heart. The blood then returns to the right side of the heart in the veins. The right side then pumps it into the lungs to absorb oxygen, and from there it drains back into the left side. Because the fetus obtains her oxygen via the placenta, her blood largely bypasses the lungs and flows directly from the right half of her heart to the left half through two special holes. This allows the fetus's heart to handle a lot of blood without any being wasted circulating through the underdeveloped vessels of the lung.

At birth the baby must change this arrangement, effectively transforming the heart from a single pump to a double pump. The way in which she does this is ingenious. As she breathes—and cries—for the first time, the blood pressure in the right side of her heart falls and flaplike valves snap shut over the holes in the heart, closing the left-to-right shunts and forcing the blood to flow through the lungs. During the next six to eight weeks, fibers grow across the shunts to seal them.•

Flow control: Heart valves develop so blood is pumped in one direction only →

CUSTOM INSULATION

The urgency of the need to start breathing is, in fact, rather less than it might be: first because the baby has a large store of glycogen (a complex carbohydrate that can be converted to lactic acid in the absence of oxygen to provide energy for some minutes), and second because the hemoglobin (the blood pigment that carries oxygen) in a baby is different from adult hemoglobin and works at lower oxygen levels.

Still, the baby has one other trick to help her adjust to the outside world: her large store of brown fat over her shoulders and neck and around her kidneys. After oxygen, a newborn baby's most urgent need is warmth, because she loses much more heat in proportion to her size than an adult or infant. The deposits of brown fat explain how a wet, inactive baby suddenly exposed to cold air can keep warm without shivering.

Packed with mitochondria, the cells of this tissue are equipped for immediate combustion of the fat to provide heat. By contrast, ordinary fatty tissue releases fat into the circulation to be used in the liver as a source of energy. If the baby gets cold, her nervous system responds by releasing epinephrine-like hormones that drive the mitochondria to burn metabolic fuel, effectively "switching on" the brown fat and warming her up. Whether it's used or not, the brown fat shrinks away within a few days.

In developed countries three-quarters of perinatal deaths occur in the 10 percent of babies who are born prematurely. Premature babies have little fat of any kind, and unless they are kept artificially warm, their temperature drops to dangerous levels. They are also more vulnerable to a temporary lack of oxygen than full-term babies are, because they may not have developed an adequate store of glycogen or enough surfactant for the lungs to hold air.•

HEATING ELEMENT

Brown fat looks like the layer of fatty tissue under the skin, but under a microscope the fat is seen to be scattered through the cells in tiny droplets instead of forming a single large drop in each cell. This electron micrograph shows a brown-fat cell surrounded by capillaries, magnified about 1,000 times. The "brown" refers to the supporting tissue rather than the fat itself.

Packing the pounds: 38-week baby →

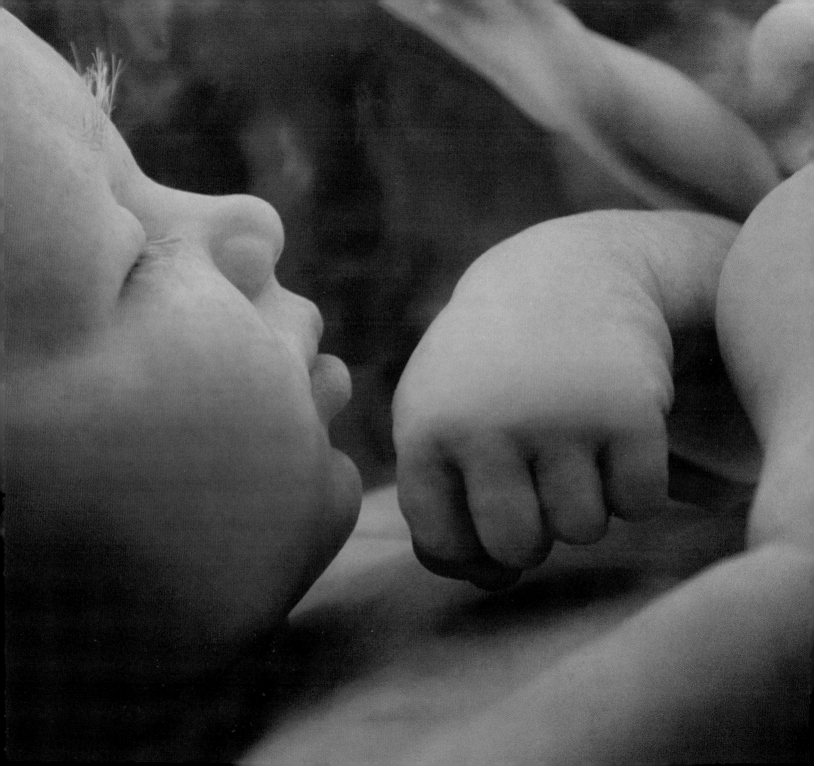

NEWBORN BABY BIRTHDAY

All her vital life systems are now working independently, and the umbilical cord can be cut. The placenta is redundant, and in the third stage of labor it detaches from the uterine wall and follows the baby out through the vagina.

After growing inside her womb for nine months, the baby finally comes face to face with her mother. The sweet smile seen on ultrasound images has gone now as the baby is thrust into a noisy, bright world and starts to feel uncomfortable sensations like cold and hunger. Her smile won't be seen again until she is at least four weeks old.

Sometimes it is necessary to deliver the baby through a surgical incision in the mother's abdominal wall and uterus—that is, by Caesarean section. Legend has it that Julius Caesar was born this way, but the operation may be named from an ancient law, restated by Caesar, that a woman dying in labor must be cut open in the hope of saving the child.

The procedure is used when the mother or baby shows signs of distress or if labor fails to progress. This could be for a number of reasons: The baby's head may be too large for the mother's pelvis, the baby might be in the wrong position, the uterine contractions could be inadequate, or the placenta may lie across the passage from the uterus and would be liable to bleed dangerously during natural labor.

Between 1970 and 1988, the rate of Caesareans in the United States rose from 5 percent of all births to nearly 25 percent, though about a third were performed not because of any particular medical problem but simply because the mother had previously had one. This suggests that we have yet to strike the right balance between ensuring the safety of the mother and the baby and avoiding this major and surgical operation.

RUNAWAY BRAIN

Each year, about 130 million women around the world go through the complex cycle of pregnancy and birth. Our increasingly sophisticated understanding of the process has drastically reduced the risks for both mother and baby. Ironically, the one thing that allows us to understand the process—our large brains—is principally responsible for the difficulties of childbirth. Most mammals, with much smaller brains and heads, have a far easier time squeezing out their offspring. Their infants are also more advanced in survival terms than our helpless babies—often able to walk, feed, and escape from predators immediately after birth. For a human baby to do this, its mother would have to undergo a 21-month pregnancy and then give birth to a toddler.

Coils of destiny: The umbilical cord, seen on the left, has either has a right or left twist, which may relate to the baby's handedness →

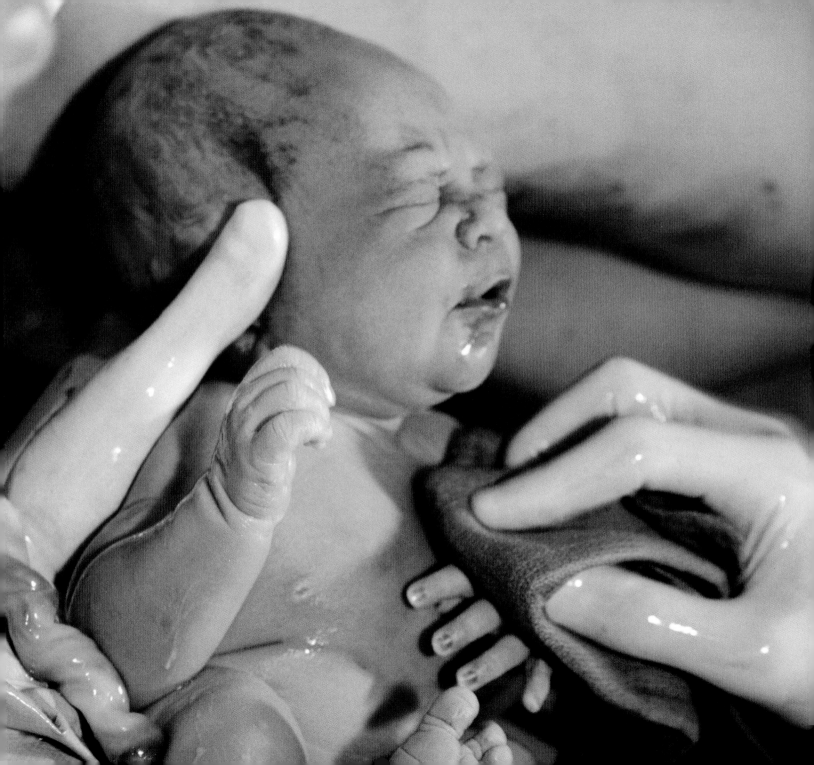

THE WORLD AT LARGE

This little girl's body, after nine months in the womb and a healthy delivery, is now on its own. Her parents will feed her and keep her warm, but for the first time, her body must keep itself alive.

Her birth marks the beginning of her journey in the world. But she has already traveled an incredible path during her odyssey in the womb. She has gone from egg, to embryo, to fetus, to trillions of cells of newborn baby.

Protected by her mother and following her own unique set of genetic instructions, she has grown a face, arms, eyes, and legs. She has a brain and nervous system to control her body, stomach, and intestines to digest food, and a heart to pump blood. She has learned to breathe, to hear, to feed, to remember, and to tell her parents when she is hungry, tired, happy, or in pain—all before being born.

Now she is ready to face the world.

Journey's end: From egg to human in 38 weeks →

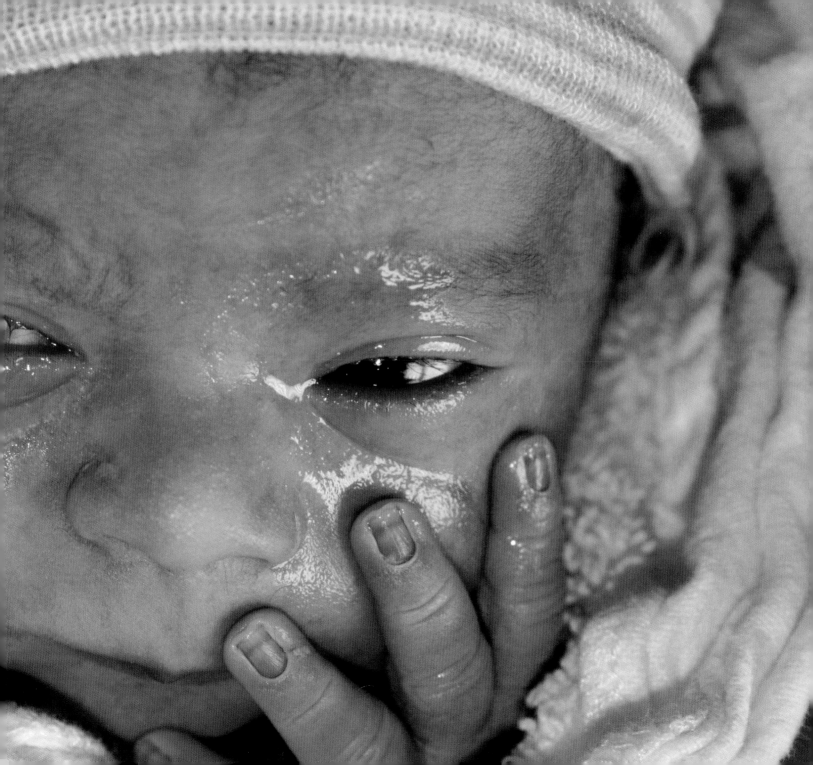

	-2	-1	1	2	3	4	5	6	7	8	9	10	11	12	13	14	15	16	17
Week	-2	-1	1	2	3	4	5	6	7	8	9	10	11	12	13	14	15	16	17
Length					0.1 in	0.2–0.3 in		0.5 in	0.7 in	1.2 in	2 in	2.4 in		3.4 in		4.7 in		5.5 in	
Weight											0.3 oz	0.5 oz		1.6 oz		3.9 oz		7.1 oz	

Main events and changes

Mother's last menstruation

Fertilization; implantation; flat embryonic disk

Mother's first missed menstrual period; cell differentiation begins

Gastrulation; folding up; brain, spinal cord, and heart begin to develop; gastrointestinal tract begins to develop

Embryo has C-shaped curve; tissue that develops into the vertebra and muscles forms; heart now beats at a regular rhythm; rudimentary blood moves through the main vessels; structures of the eyes and ears begin to form; the brain develops into five areas, and some nerves from the brain and spinal cord are visible; arms and leg buds are visible

Gonads forming; the lungs begin to develop; arms and legs lengthened with foot and hand areas distinguishable

Nipples and hair follicles form; elbows and toes visible; all essential organs have at least begun to form

Pregnancy detectable by physical examination; head has human characteristics; eyelids are more developed; external features of the ear begin to take their final shape

Eyelids closing or closed; head round; external genitalia still not distinguishable as male or female; intestines in umbilical cord

Responds to stimulation; form recognizably human; early fingernail development

Essential organs basically formed; circulatory system working; sex distinguishable externally; well-defined neck; red blood cells are produced in the liver; fist can be made with the fingers

Mother's abdomen visibly distended; skeleton visible in x-rays; head erect; legs well developed; early toenail development

Sucking movements; sex organs distinct; ears stand out from head; meconium is made in the intestinal tract

EMBRYONIC PERIOD

18	19	20	21	22	23	24	25	26	27	28	29	30	31	32	33	34	35	36	37	38
6.3 in		7.5 in		8.3 in		9.1 in		9.8 in		10.6 in		11.0 in		11.8 in				13.4 in		14.2 in
11.3 oz		1.0 lb		1.4 lb		1.8 lb		2.2 lb		2.9 lb		3.7 lb		4.6 lb				6.4 lb		7.5 lb

Vernix caseosa covers skin; quickening movements can be felt by mother

Head and body covered with hair; vigorous movement with increased muscle development

Survival outside the womb possible with medical help; skin wrinkled and red

Fingernails present; eyebrows appear; all eye components are developed; lean body; hand and startle reflex; footprints and fingerprints forming; air sacs forming in lungs

Survival outside the womb probable with medical help; eyes partially open; eyelashes present

Eyes open; good head of hair; skin slightly wrinkled; storage of iron, calcium, and phosphorus begins

Layer of fat forming beneath skin; toenails present; testes descending

Fingernails extend to fingertips; skin smooth

Survival outside the womb expected without medical help

Body usually plump; body hair almost absent; toenails extend to toe tips; flexed limbs; firm grasp

Normal birth; prominent chest; small breast buds protrude on both sexes; testes in scrotum or groin; fingernails extend beyond fingertips

FETAL PERIOD

FURTHER READING

There are several excellent books for expectant mothers—and fathers—that explain what is happening week by week during pregnancy. Three of the best are:

Campbell, Stuart. *Watch Me Grow: A Unique, 3-Dimensional Week-by-Week Look at Your Baby's Behavior and Development in the Womb*. St. Martin's Press, 2004.

Gordon, Yehudi. *Birth and Beyond*. Vermilion, 2002.

Regan, Lesley. *Your Pregnancy Week by Week*. Dorling Kindersley, 2005.

Two classics offer solid and extensive practical advice to mothers about the changes and challenges they will face during pregnancy:

Murkoff, Heidi E., Arlene Eisenberg, and Sandee E. Hathaway. *What to Expect When You're Expecting*, 3rd edition. Workman, 2002.

Lichtman, Ronnie, Lynn Louise Simpson, and Allan Rosenfield. *Dr. Guttmacher's Pregnancy, Birth, and Family Planning*, revised and updated. New American Library, 2003.

Popular books for a general audience that focus to varying extents on the events in the baby's journey of development are numerous. The most outstanding contribution so far is:

Bainbridge, David. *Making Babies: The Science of Pregnancy*. Harvard University Press, 2001.

By comparing pregnancy in humans with that in animals, Bainbridge's book offers fascinating details in a lively and clear style. Other recent works include:

Nilsson, Lennart, and Lars Hamberger. *A Child Is Born*, 4th edition. Delacorte, 2003.

Tsiaras, Alexander, and Barry Werth. *From Conception to Birth: A Life Unfolds*. Doubleday, 2002.

Wolpert, Lewis. *The Triumph of the Embryo*. Oxford University Press, 1991.

Development—normal and abnormal, human and non-human—is well covered by:

Carroll, Sean B. *Endless Forms Most Beautiful: The New Science of Evo Devo and the Making of the Animal Kingdom*. W. W. Norton and Company, 2005.

Leroi, Armand Marie. *Mutants: On Genetic Variety and the Human Body*. Viking, 2003.

For popular books on human genetics, try:

Jones, Steve. *The Language of the Genes*. Doubleday, 1993.

Pollack, Robert. *Signs of Life: The Language and Meanings of DNA*. Houghton Mifflin, 1994.

Ridley, Matt. *Genome: The Autobiography of a Species in 23 Chapters*. Harper Collins, 2000.

Watson, James D, and Andrew Berry. *DNA: The Secret of Life*. Knopf, 2003.

Current thinking about fetal behavior is summarized easily in:

Hopson, Janet L. "Fetal Psychology." *Psychology Today* (Sept./Oct. 1998), 44.

A readable account of the complex topic of immunology is provided in a special issue of *Scientific American*:

"Life, Death, and the Immune System." *W. H. Freeman*, 1994.

More on the fetal origins of disease can be found in:

Barker, D. J. P. *Mothers, Babies, and Health in Later Life*, 2nd edition. Churchill Livingstone, 1998.

Barker, D. J. P., editor. *Fetal and Infant Origins of Adult Disease*. BMJ Books, 1992.

"The Child Is Father to the Patient." *The Economist* (12 June 2003).

Robinson, Roger. "The fetal origins of adult disease." *British Medical Journal* (17 Feb 2001), 375–6.

The most recent information about a baby's journey from conception to birth is scattered in many different scientific journals. The best way of digging deeper is by referring first to references in textbooks. Among the more useful ones are:

Blackburn, Susan Tucker. *Maternal, Fetal, and Neonatal Physiology: A Clinical Perspective*, 2nd edition. Saunders, 2003.

Carlson, Bruce M. *Human Embryology and Developmental Biology*. Mosby, 2004.

Cunningham, F. Gary, et al. *Williams Obstetrics*, 22nd edition. McGraw-Hill, 2005.

Danforth, David N., Ronald S. Gibbs, Beth Y. Karlan, Arthur F. Haney, editors. *Danforth's Obstetrics and Gynecology*, 9th edition. Lippincott Williams & Wilkins, 2003.

England, Marjorie A. *Life Before Birth*, 2nd edition. Mosby-Wolfe, 1996.

Gilbert, Scott F., and Susan R. Singer. *Developmental Biology*. Sinauer, 2006.

Moore, Keith L., and T. V. N. Persaud. *Before We Are Born: Essentials of Embryology and Birth Defects*, 6th edition. Saunders, 2003.

The Internet is rapidly overtaking the printed word for scientific literature, and there are several excellent sites that keep up to date with modern biology. Among them are:

Google Scholar: http://scholar.google.com
HighWire Press: http://highwire.stanford.edu
PubMedCentral: http://pubmedcentral.nih.gov

GLOSSARY

The following list of brief explanations is confined to terms with which you may not already be familiar or which you will find used frequently in the book.

Allantois A fetal membrane or sac derived from the early endoderm, much of which protrudes from the naval. The portion inside the fetus forms most of the bladder, whereas the portion outside combines with the connecting stalk to form the umbilical cord.

Amnion The innermost of two fetal membranes that enclose the embryo. Derived from the early ectoderm, it lies inside the trophoblast.

Amniotic fluid The watery fluid surrounding and cushioning the growing fetus inside the amniotic sac.

Amniotic sac A pair of membranes, which contain the embryo (and later fetus) until shortly before birth. The inner membrane, the amnion, contains the amniotic fluid and the fetus. The outer membrane, the chorion, contains the amnion and is part of the placenta.

Antibody Any of various proteins of the immune system produced in the blood in response to an antigen. By attaching to antigens on infectious organisms antibodies can render them harmless or cause them to be destroyed.

Antigen A substance that stimulates the production of antibodies.

Birth canal The cervix and vagina.

Blastocyst A sphere of cells (trophoblast) enclosing at one side a clump of cells (the inner cell mass) destined to become the embryo proper and a fluid-filled cavity.

Brown fat Cells that internally breakdown fatty acids, directly releasing heat. Similar to fat in hibernating animals, these disappear in humans shortly after birth.

Cell The smallest biological unit capable of independent life, by means of self-replication and metabolism.

Cervix The muscular neck of the lower part of the uterus that extends into the vagina.

Chorion The outer of the two fetal membranes that forms a sac around the embryo and which contributes to the placenta.

Chorionic villi Finger-like projections of chorion in the placenta which increase contact between the embryonic and maternal tissues.

Chromosome A long molecule of DNA.

Cilia The short threads projecting from the surface of a cell or organism whose rhythmic beating causes movement of the organism.

Connecting stalk A stem suspending the yolk sac and amnion from the inside of the chorion. Derived from early mesoderm, it forms the vessels of the umbilical cord.

Corpus luteum A temporary structure on the ovary which secretes progesterone.

Differentiation The process by which unspecialized cells change during development to acquire the characteristics and functions of more specialized forms.

DNA (deoxyribonucleic acid) The molecule responsible for heredity that carries along its length the chemical letters of the genetic code. The sequence of letters encodes the sequence of amino acids in proteins. In humans, the DNA is arranged into 23 pairs of distinct chromosomes in the nucleus.

Down syndrome A syndrome that occurs because a baby inherits two copies of a certain chromosome from its mother instead of one. The syndrome is characterized by a typical facial and body shape, heart abnormalities, and reduced life expectancy.

Ectoderm A layer of cells that forms on the top of the early embryo, and which forms the amnion, the nervous system, and the outer layer of skin.

Egg The female germ cell or sex cell produced in the ovaries.

Embryo A developing human during the period when most of its internal organs are forming (before eight weeks).

Embryonic disk The three-layered sandwich of cells (ectoderm, mesoderm, and endoderm) that forms the early embryo.

Endocrine glands Organs that release hormones into the blood.

Endoderm A layer of cells that forms on the bottom of the early embryo, and which folds in on itself to form the gut, lungs, yolk sac, amnion, and allantois.

Enzyme A protein catalyst responsible for speeding up biochemical reactions.

Epinephrine A hormone secreted by the adrenal gland in response to stress. It increases heat rate, pulse rate, and blood pressure, and raises the blood level of glucose and lipids (a group of fats and related substances). Also known as adrenaline.

Estrogens A group of related steroid hormones involved in the development of the female body, the menstrual cycle, pregnancy, and lactation.

Fallopian tube Either of a pair of slender tubes through which mature eggs pass from the ovaries to the uterus.

Fertilization The union of male and female germ cells (sperm and egg).

Fetus A developing human after the time when most of its internal organs have formed (after eight weeks).

Gene A stretch of DNA whose sequence of chemical letters spells out the information needed to make a particular protein. Parents pass on characteristics to their offspring through their genes.

Germ cell A sexually reproductive cell (the sperm or egg).

Gonad The organ in which sperm or eggs are produced (the testis or ovary).

Hormone A chemical substance produced in an endocrine gland and transported in the blood to a certain tissue, on which it exerts a specific effect, such as metabolism or growth.

Human chorionic gonadotrophin A hormone produced by the placenta that maintains the corpus luteum during pregnancy.

Identical twins Also called monozygotic. Twins derived from a single egg.

Implantation The attachment of the blastocyst to the wall of the uterus.

Inner cell mass A population of cells that forms inside the trophoblast when the embryo reaches the blastocyst stage. The inner cell mass forms the fetus, all the fetal membranes except the outermost one, and the blood vessels and connective tissue of the placenta.

Lanugo A layer of fine hairs covering the fetus before birth.

Meconium Greenish fluid, mostly bile and mucus, in the fetus's intestine, passed soon after birth (or before birth if labor is difficult and the baby is distressed).

Menstruation The roughly monthly discharge of blood and cellular debris from the uterus by non-pregnant women of childbearing age. Nontechnical name: period.

Mesoderm A layer of cells that forms in the middle of the early embryo and which forms most of the fetus.

Metabolism The sum total of the chemical processes that occur in living organisms, resulting in growth, production of energy, elimination of waste material, and so on.

Myelin A white tissue forming an insulating sheath around certain nerve fibers.

Neuron A cell that conducts nervous impulses.

Norepinephrine Also known as noradrenaline. Related to epinephrine, this substance relaxes structures such as blood vessels in muscles.

Non-identical twins Also called dizygotic. Twins derived from two separate eggs.

Notochord A rod that forms in the embryonic mesoderm and which establishes the front-to-back orientation of the embryo. It also initiates the formation of the nervous system, the skeleton, and most muscles.

Nucleus The spherical membrane-enclosed "control center" inside cells that contains the chromosomes and associated molecules that govern cell characteristics and growth.

Oxytocin A protein hormone secreted by the pituitary which is involved in stimulating contraction of the uterus, milk secretion, parental bonding, and the shrinking of the uterus after birth.

Perinatal About three months before to about one month after birth.

GLOSSARY

Period A nontechnical name for an occurrence of menstruation.

Pituitary gland A small endocrine gland attached by a stalk to the base of the brain that produces hormones affecting skeletal growth, development of the sex glands, and the functioning of the other endocrine glands.

Placenta An organ produced by the interaction of the mother and the embryo that allows the embryo to get nourishment from its mother and discard waste.

Premature The term traditionally used to describe an infant if its birth weight is less than 5.5 pounds. Because newborn babies are not all the same size, however, a premature baby is better defined as one born three or more weeks too soon.

Prenatal Before birth; during pregnancy.

Progesterone A steroid hormone secreted by the corpus luteum and the placenta. It participates in the menstrual cycle and is essential for pregnancy, stimulating development of the uterus to receive a fertilized egg, and nourish the embryo.

Prostaglandins A group of fat-derived chemical messengers produced by a variety of tissues. Among other things, prostaglandins are involved in the destruction of the corpus luteum and the process of labor.

Protein A molecule produced by the linking together of smaller units called amino acids. Proteins have a huge variety of shapes and functions and form most of life's machinery.

Receptors Molecules carried by many body cells, which bind to incoming messenger molecules (hormones, for example) and mediate their effects on the cell.

Reflex An involuntary response to a stimulus determined by impulses in nerves.

Semen The sperm-containing fluid produced by males.

Sex chromosomes Specialized chromosomes that carry the genes that determine the sex of an individual. A Y chromosome usually leads to a male appearance. At least one X chromosome is essential for life, so women are usually XX and men are XY.

Sperm The male germ cell or sex cell produced in the testes.

Stem cell An unspecialized cell that gives rise to a specific specialized cell, such as a blood cell. A stem cell from an early embryo (an embryonic stem cell) can produce any kind of cell in the body and has the capacity for self-renewal. Medical researchers believe stem cells have the potential to change the face of human disease by being used to repair specific tissues or to grow organs.

Steroids A diverse group of hormones made from cholesterol. They include estrogens and progesterones.

Surfactant A detergent-like molecule produced by the lungs which reduces the amount of work the chest must do to expand the tiny air spaces in the lungs.

Trimester A period consisting of three calendar months. Obstetricians commonly divide the nine-month period of pregnancy into three trimesters, each demarcating significant milestones in fetal development.

Trophoblast The outer part of the blastocyst, which eventually forms the outer layer of the placenta and fetal membranes.

Umbilical cord The structure that connects the fetus's navel with the placenta. It contains the large umbilical vessels.

Vernix Also known as vernix caseosa. The waxy or cheesy white substance coating the skin of newborn babies.

Yolk sac A fetal membrane derived from the early endoderm which protrudes from the navel. It forms part of the gut and generates primitive blood cells and germ cells.

Zona pellucida A thick clear gelatinous coat that surrounds the egg.

ACKNOWLEDGMENTS

I owe a debt of gratitude to the many people involved in the making of the National Geographic Channel television special *In the Womb*, in particular Toby Macdonald for writing the script on which the book is based, Genevieve Sexton for her invaluable contributions to the research and writing, Garrett Brown for his helpful leads on the contents, Julia Behar and Melanie Wood for tracking down the right images, and Alom Shaha for suggesting the book in the first place and putting me in touch with Julia, who deserves a further vote of thanks for making it all happen. Thanks also to Caz Hildebrand and Patrick Walsh for moral support during the book's rapid gestation, and, last but not least, to Alexa Geiser for patiently nurturing not just me and the book but Clara, too—who took a little longer.
PETER TALLACK

IN THE WOMB television special credits:
Written, Produced, and Directed by **Toby Macdonald**
Assistant Producer, **Katherine Dart**
Executive Producer, **Stuart Carter**
Special Effects, **Artem, The Mill**
Special Effects Photography, **David Barlow**
Head of Development, **Jeremy Dear**
Head of Production, **Kirstie McLure**
Executive Producer for the National Geographic Channel,
 Jenny Apostol

To order the original *In the Womb* television special on DVD, visit us online at www.shopngvideos.com or call toll-free 1-800-627-5162.

Acknowledgments for the television special *In the Womb*: With thanks to Stuart Carter who had always wanted to make the definitive film on human gestation; to Toby Macdonald, who through his visual excellence brought this extraordinary story to life; and to Professor Stuart Campbell for his guidance and help in facilitating the film.
JULIA BEHAR

PHOTOGRAPHIC ACKNOWLEDGMENTS
Artem: page 11.
David Barlow: pages 5, 7,14-15,17,26,45,51,53,55,56,59,60-61,73,74-75,77,95,96-97,102-103,105,109,111, 113,117,119, 125, 131,133,141,143.
Getty Images: page 145, Steve Satushek.
iStockphoto.com/Juan Collado: page 147.
Professor Stuart Campbell: pages 12,69,80,81,83,90,91,99, 121,123.
Pioneer Productions: pages 1,2-3,10,23,25,27,29,30,49,85,89, 107,135.
Science Photo Library: pages 67; 19, Susumu Nishinaga; 21, 35, Pascal Goetgheluck; 31, Biophoto Associates; 33,65 Steve Gschmeissner; 63, Professor P.M. Motta & E. Vizza; 87, Tissuepix; 37, Professor P.M. Motta, Dept. of Anatomy, University "La Sapienza," Rome; 137, Alfred Pasieka; 79, Innerspace Imaging; 139,142, Professor S. Cinti; 101, D. Phillips; 115, David Parker; 129, Manfred Kage; David Shook, page 41.

To order the original *In the Womb* television special on DVD outside the U.S.A., visit www.rocketrights.com.

ABOUT THE WRITERS

PETER TALLACK began his academic career studying preclinical medicine at St Mary's Hospital, London, before switching to a degree in genetics at University College London. He graduated in 1989 and then worked for nearly 10 years on the editorial staff of the international science journal *Nature,* where he was, among other things, book reviews and commentary editor. He has written about science for numerous publications including *The London Times, Sunday Telegraph,* and *The Economist;* contributed to *The Greatest Inventions of the Last 2,000 Years* edited by John Brockman (2000); and is the editor of *The Science Book* (2001). He divides his time between London and Devon, where he lives with his three children, Hester, Edmund, and Clara, who was born during the writing of this book.

HEIDI MURKOFF is the author of *What to Expect When You're Expecting,* now in its third edition, and the *What to Expect* series of parenting books (www.whattoexpect.com). She is the cofounder of the What to Expect Foundation (www.whattoexpect.org), a nonprofit organization dedicated to helping low-income families expect healthy pregnancies, safe deliveries, and happy babies. Heidi and her husband, Erik, have two children and live in California.

INDEX

Page numbers in *italic* refer
to illustrations.

INDEX

IN THE WOMB
by **Peter Tallack**

Published by the National Geographic Society
John M. Fahey, Jr., President and Chief Executive Officer
Gilbert M. Grosvenor, Chairman of the Board
Nina D. Hoffman, Executive Vice President;
 President, Book Publishing Group

Prepared by the Book Division
Kevin Mulroy, Senior Vice President and Publisher
Marianne R. Koszorus, Design Director
Barbara Brownell Grogan, Executive Editor

Staff for this Book
Garrett W. Brown, Editor
Gary Colbert, Production Director
Judith Klein, Consulting Editor
Rebecca Hinds, Managing Editor

This book was produced for the National Geographic Society
by **Here+There** www.hereandtheregroup.com
Caz Hildebrand, Art Director
Mark Paton, Designer
Genevieve Sexton, Researcher
James Kingsland, Copy Editor
Julia Behar, Picture Editor
Melanie Wood, Picture Researcher
Vanessa Bird, Indexer

Printed in Singapore by **Imago**

Founded in 1888, the National Geographic
Society is one of the largest nonprofit scientific
and educational organizations in the world. It
reaches more than 285 million people
worldwide each month through its official
journal, NATIONAL GEOGRAPHIC, and its four other magazines; the National
Geographic Channel; television documentaries; radio programs; films;
books; videos and DVDs; maps; and interactive media. National
Geographic has funded more than 8,000 scientific research projects
and supports an education program combating geographic illiteracy.

For more information, please call 1-800-NGS LINE (647-5463)
or write to the following address:

National Geographic Society
1145 17th Street N.W.
Washington, D.C. 20036-4688 U.S.A.

Log on to nationalgeographic.com; AOL Keyword: NatGeo.

For information about special discounts for bulk purchases,
please contact National Geographic Books Special Sales:
ngspecsales@ngs.org

ISBN-10: 1-4262-0003-X
ISBN-13: 978-1-4262-0003-8

Library of Congress Cataloging-in-Publication Data

Tallack, Peter.
 In the Womb / by Peter Tallack ; [foreword by Heidi Murkoff].
 p. ; cm.
 "This book originates from a television documentary originally shown in 2005 on the
National Geographic Channel in the US and channel 4 in the UK"--Introd.
 Includes bibliographical references and index.
 Summary: "An illustrated journey from conception to birth, based on the latest
research and featuring images created with newly developed, state-of-the-art 3D and
4D ultrasound technology"--Provided by publisher.
 ISBN-13: 978-1-4262-0003-8 (hardcover : alk. paper)
 1. Embryology--Pictorial works. 2. Pregnancy--Pictorial works. 3. Childbirth--
Pictorial works. 4. Fetus--Growth--Pictorial works. I. National Geographic Society
(U.S.) II. Title.
 [DNLM: 1. Embryonic Development--Pictorial Works. 2. Embryonic Development--
Popular Works. 3. Fetal Development--Pictorial Works. 4. Fetal Development--Popular
Works. WQ 17 T147i 2006]
 RG525.T35 2006
 618.2002'2--dc22
 2006010891